A MILLION WAYS TO
DIE
HARD

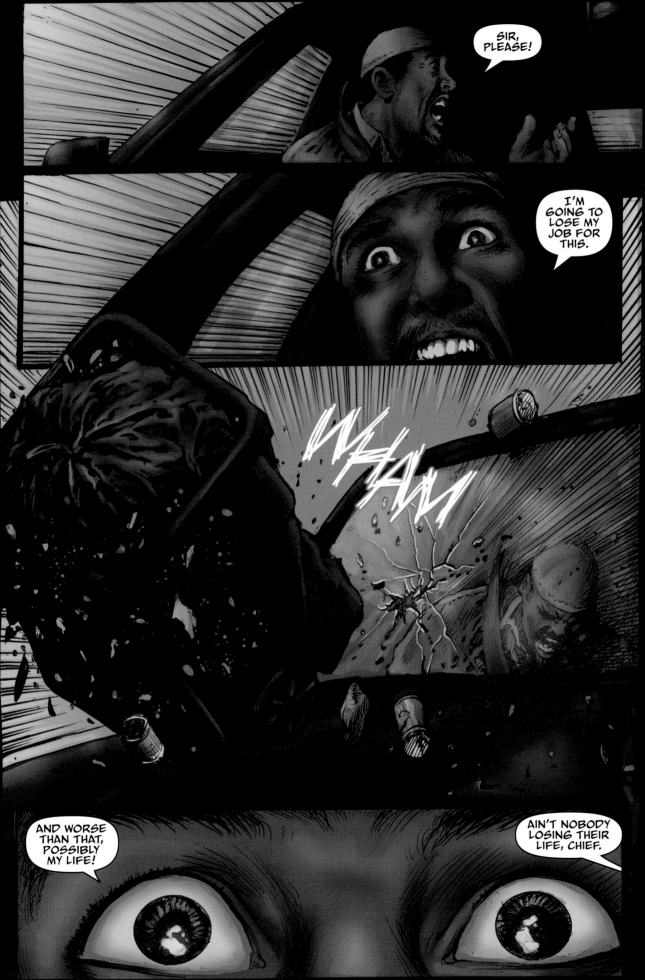

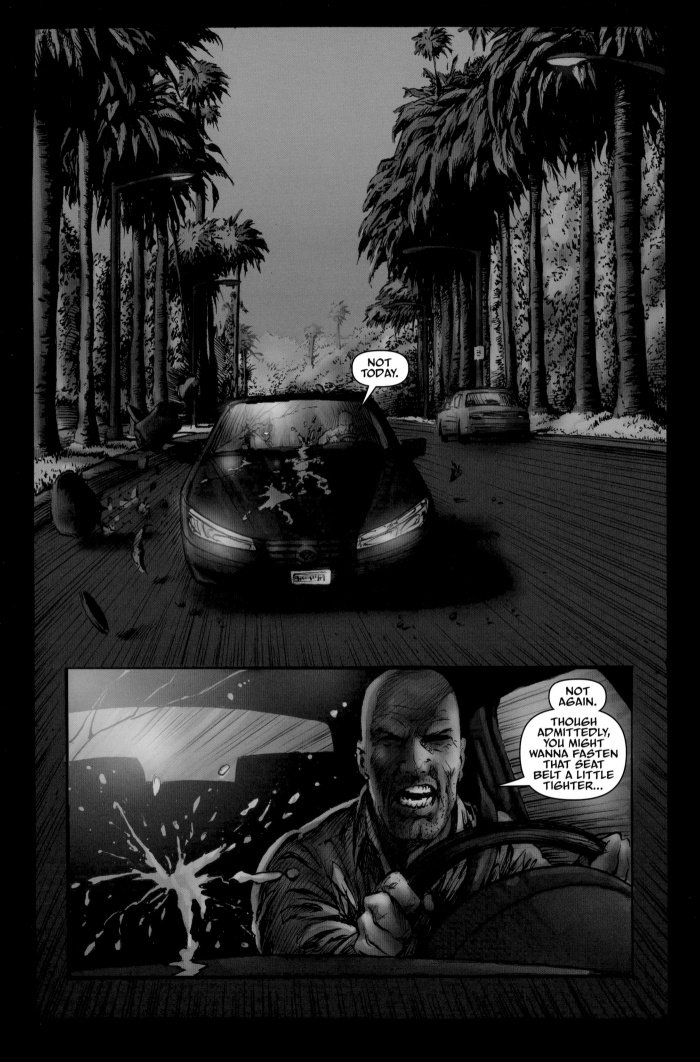

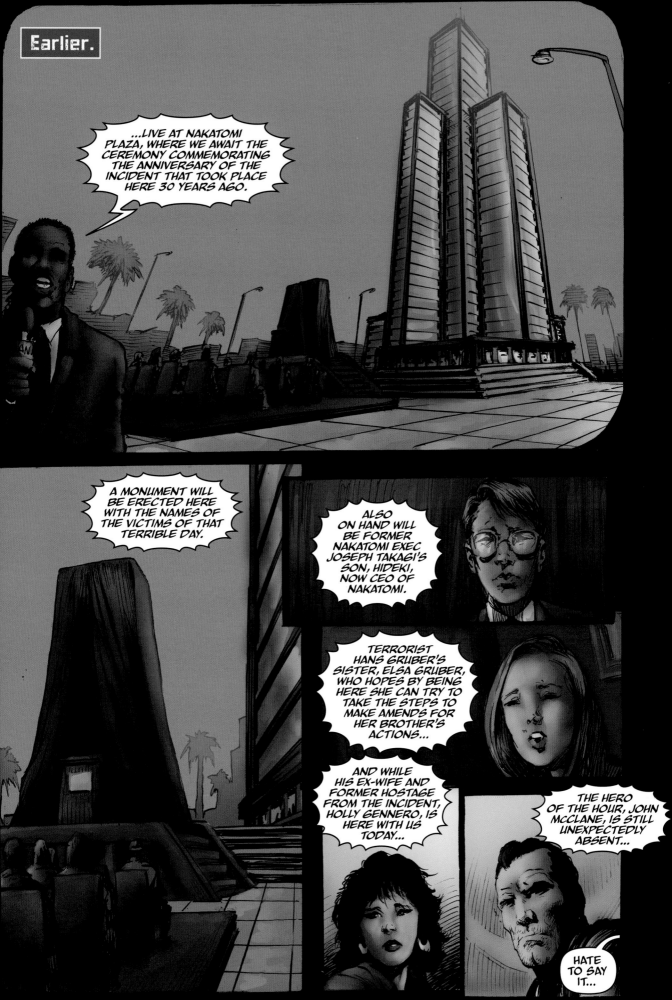

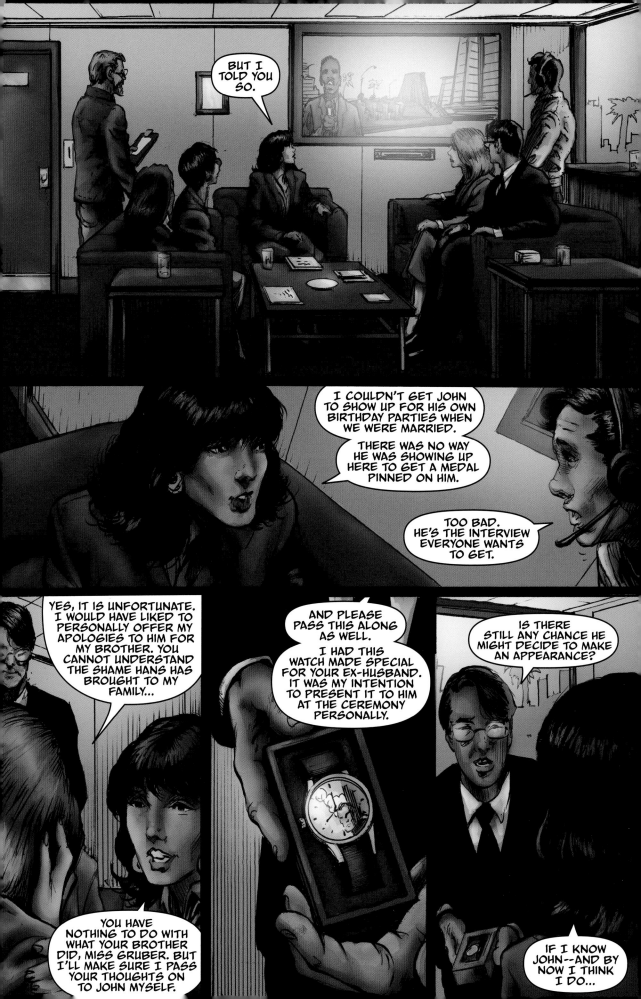

"HE'S IN A BAR
SOMEWHERE
WATCHING THIS
ALL ON TV.

"AND DRINKING
TOO MUCH."

LET ME
GET ANOTHER
ONE OF THOSE,
PAL.

WHAT ARE
THEY CALLED
AGAIN?

MCCLANE, WHO HAS SINCE RETIRED FROM THE NYPD, STOPPED TERRORISTS 30 YEARS AGO...

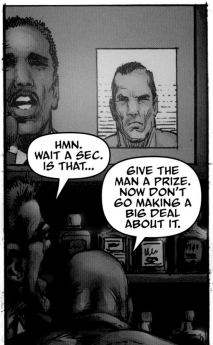

HMN. WAIT A SEC. IS THAT...

GIVE THE MAN A PRIZE. NOW DON'T GO MAKING A BIG DEAL ABOUT IT.

FZZZZ

AND DO SOMETHING ABOUT YOUR CRAPPY RECEPTION, OKAY?

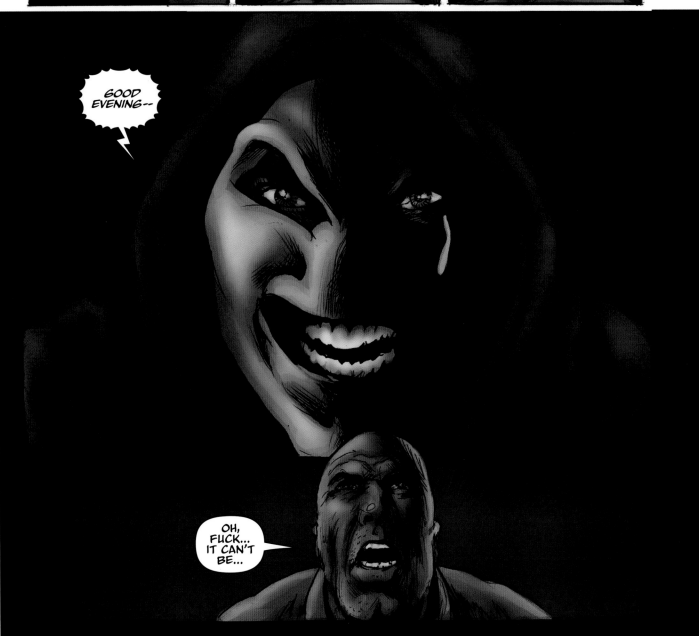

GOOD EVENING--

OH, FUCK... IT CAN'T BE...

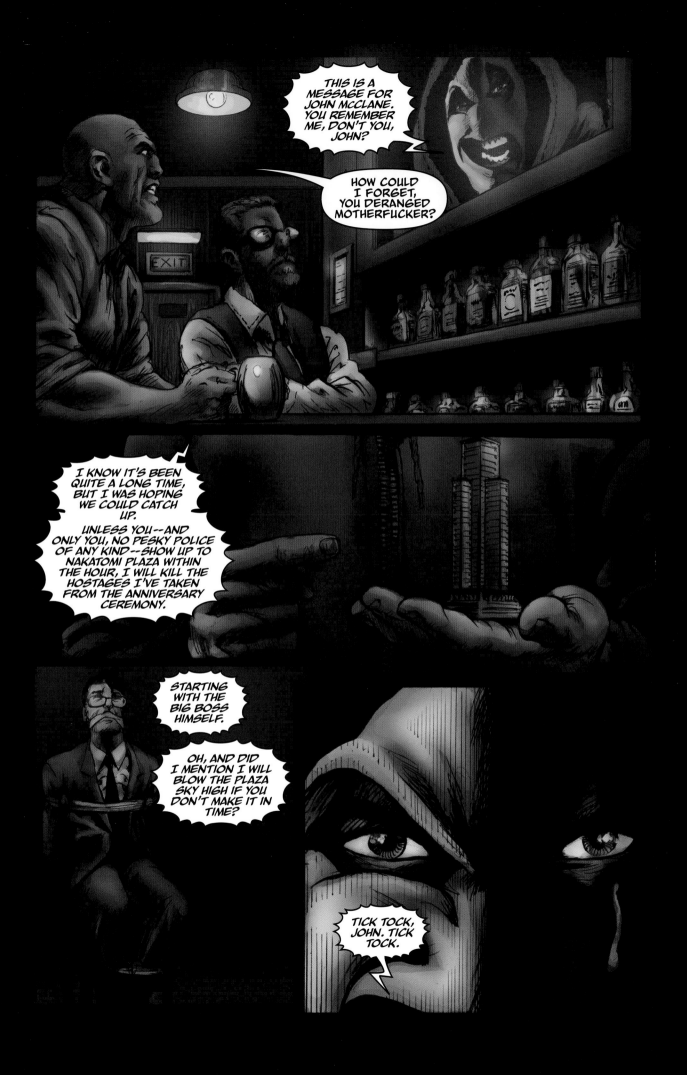

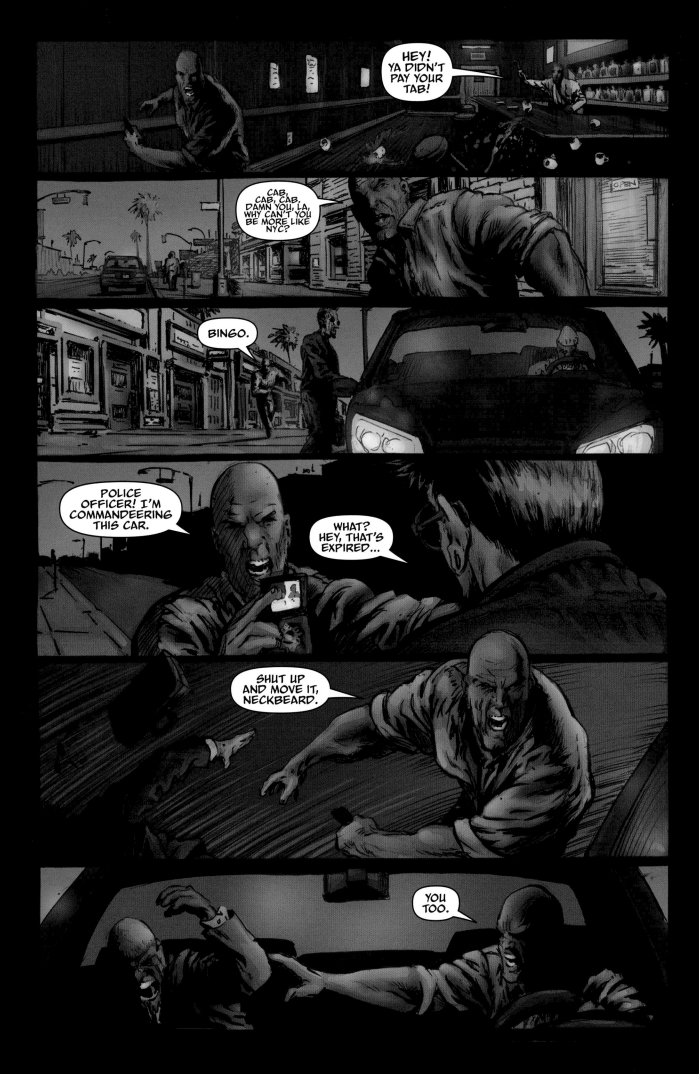

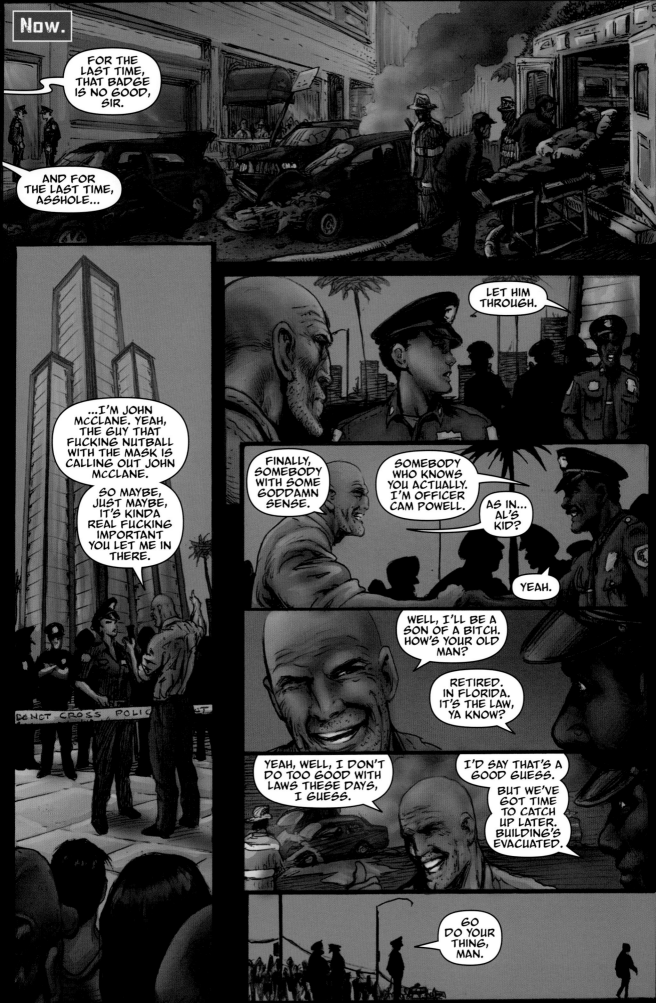

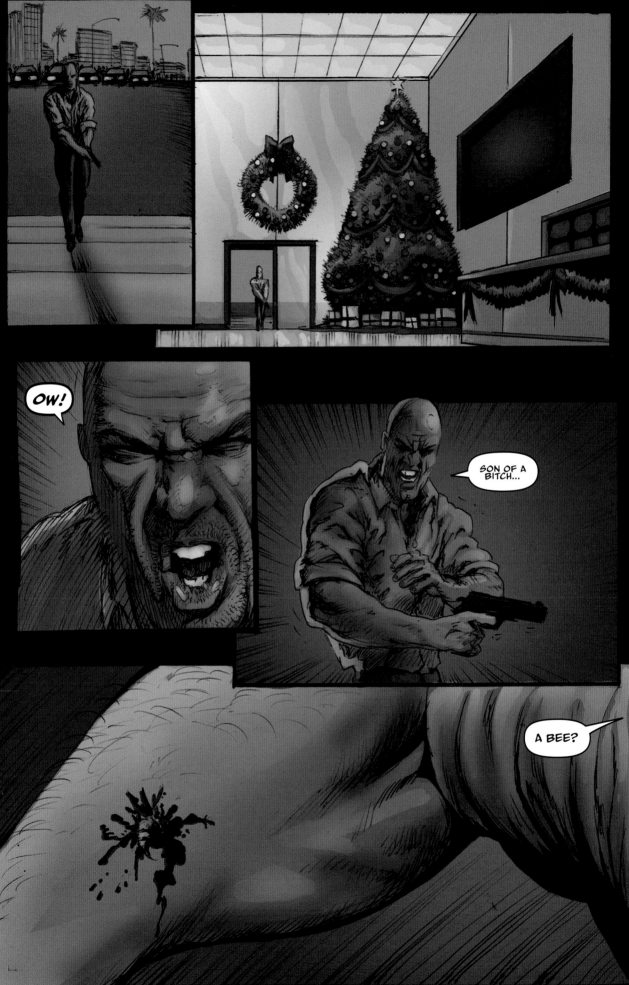

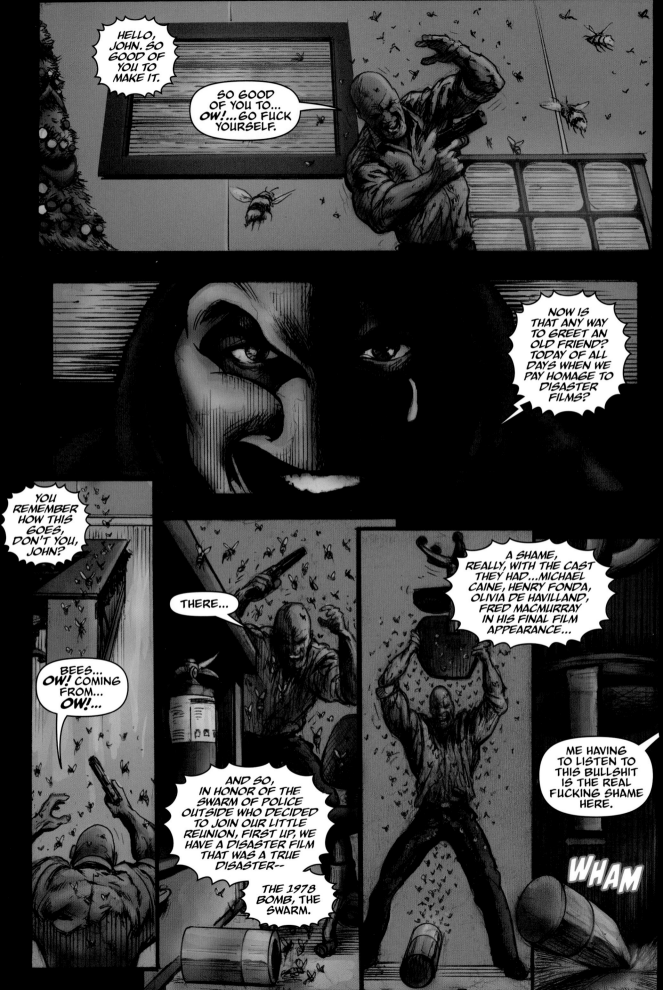

TSK TSK. THAT'S NOT THE KIND OF ATTITUDE THAT'S GOING TO SAVE TAKAGI, NOW, IS IT?

TOO LATE TO CHANGE MY ATTITUDE AT THIS POINT.

AND IT'S GONNA BE TOO LATE FOR YOU IF YOU DON'T TELL ME WHERE TAKAGI AND THE OTHER HOSTAGES ARE.

PSSSSSSSSSS

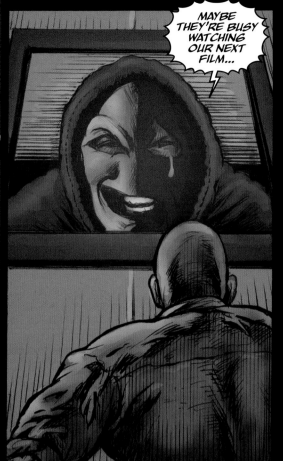

MAYBE THEY'RE BUSY WATCHING OUR NEXT FILM...

EARTHQUAKE!

OH, HELL NO...

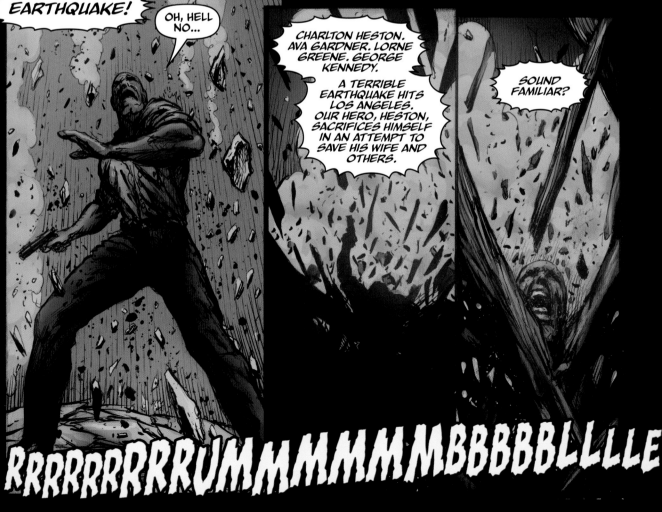

CHARLTON HESTON. AVA GARDNER. LORNE GREENE. GEORGE KENNEDY.

A TERRIBLE EARTHQUAKE HITS LOS ANGELES. OUR HERO, HESTON, SACRIFICES HIMSELF IN AN ATTEMPT TO SAVE HIS WIFE AND OTHERS.

SOUND FAMILIAR?

RRRRRRRRUMMMMMMMBBBBBLLLLE

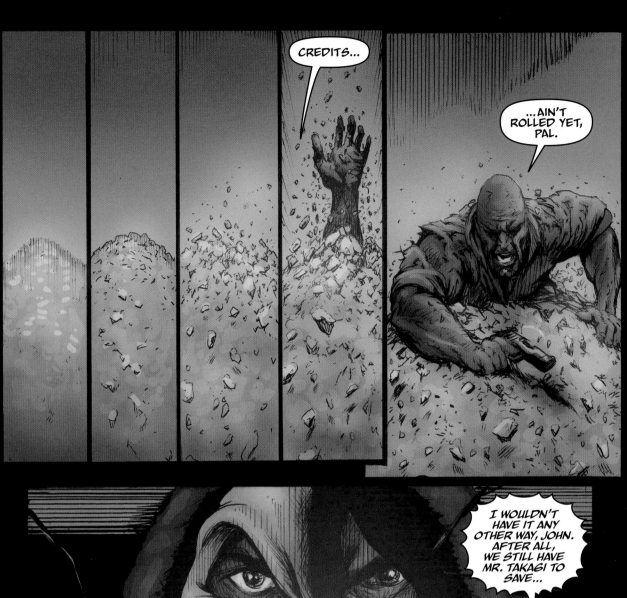

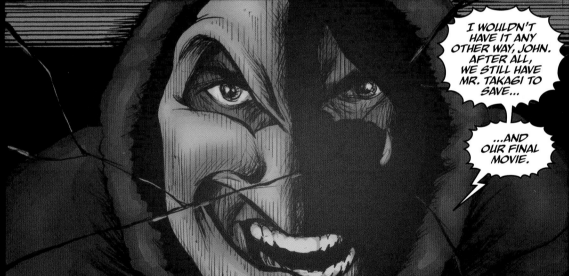

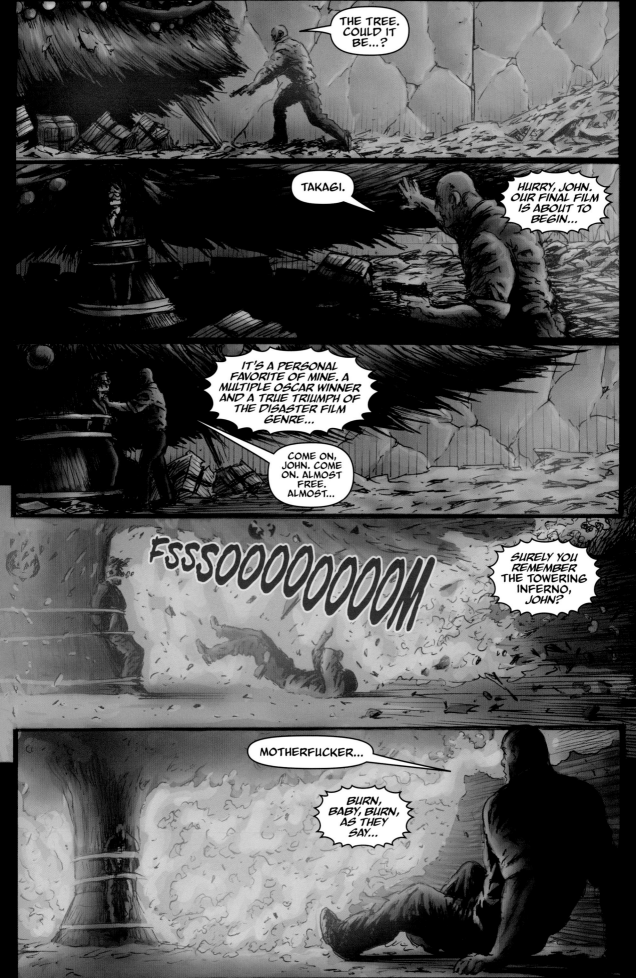

CHAPTER Z

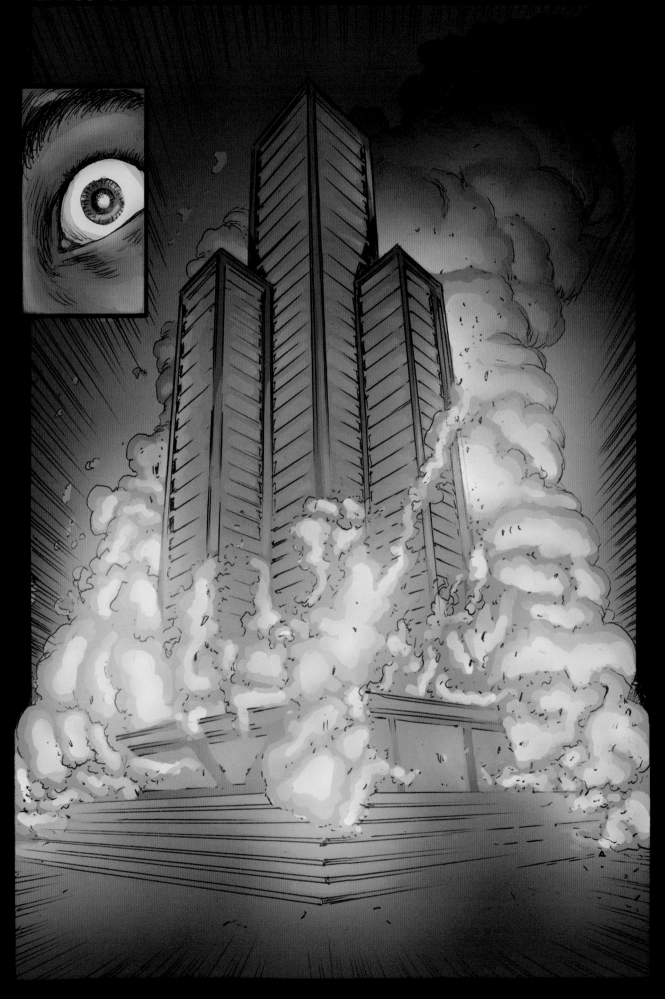

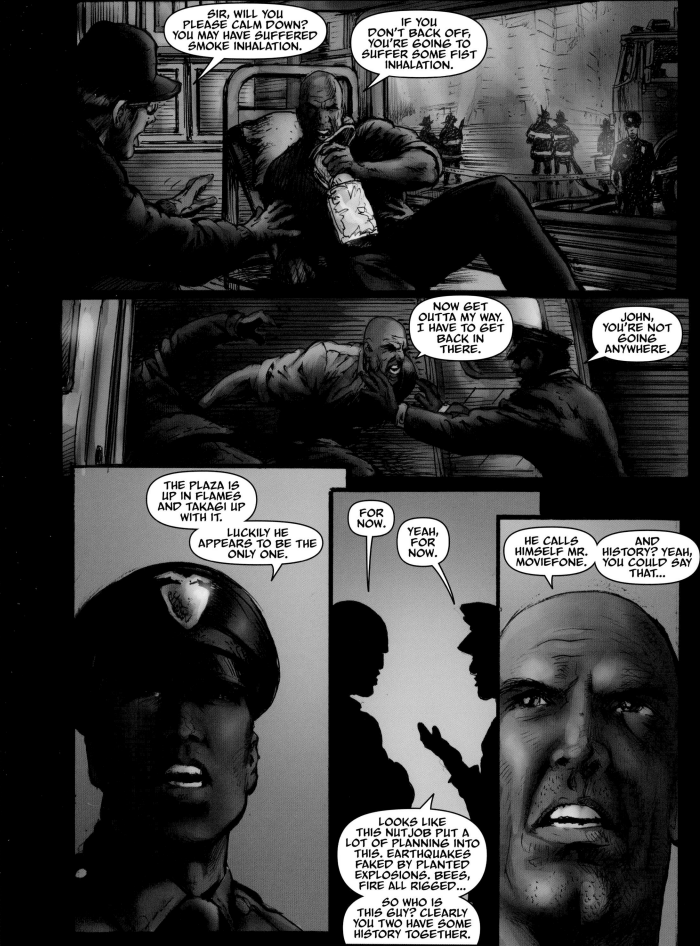

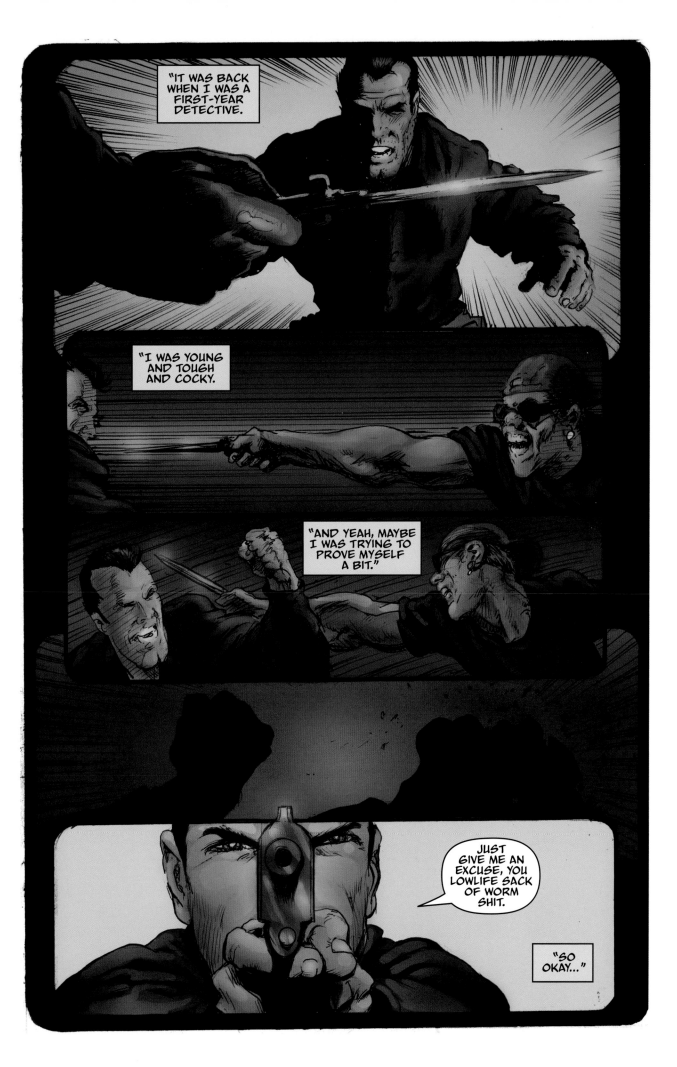

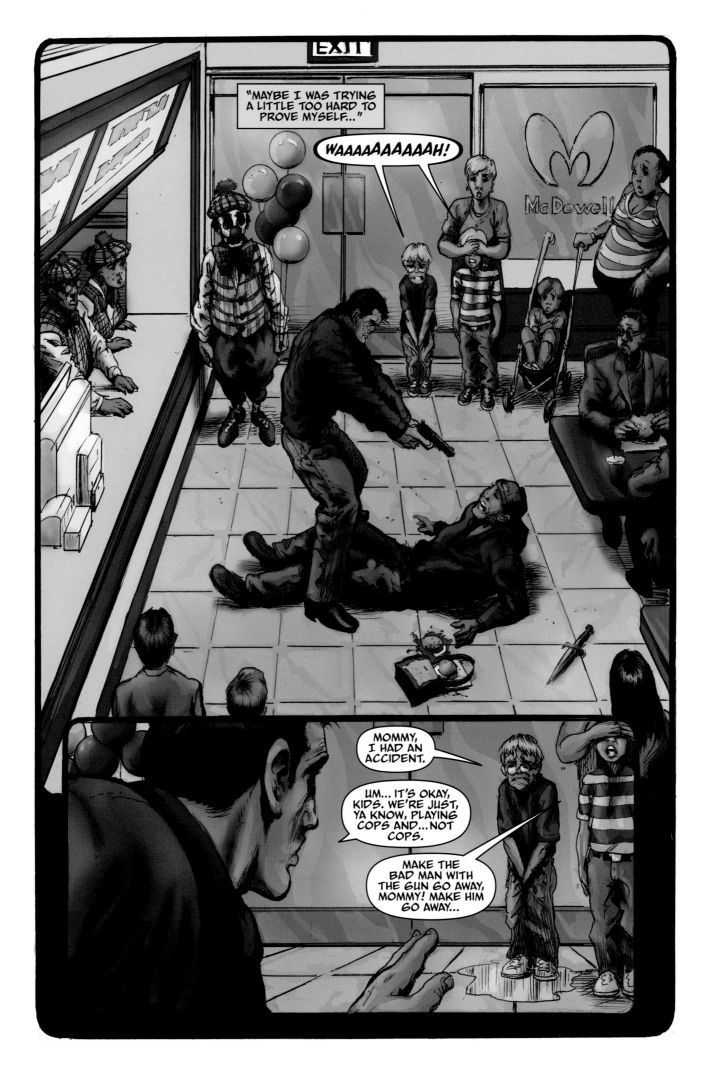

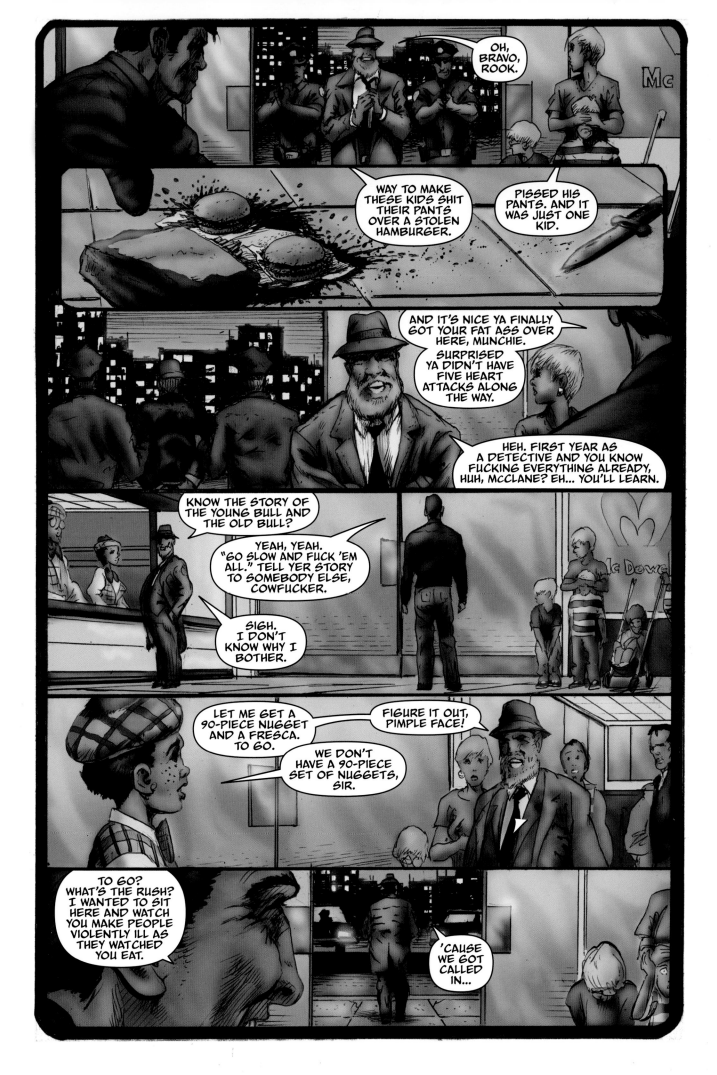

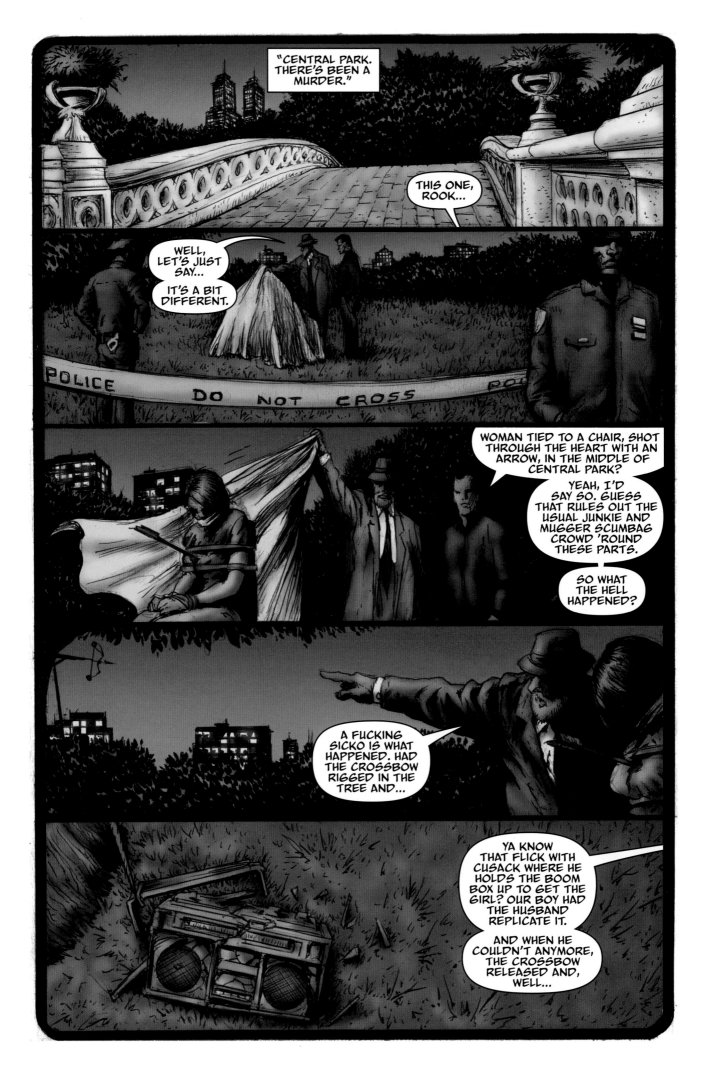

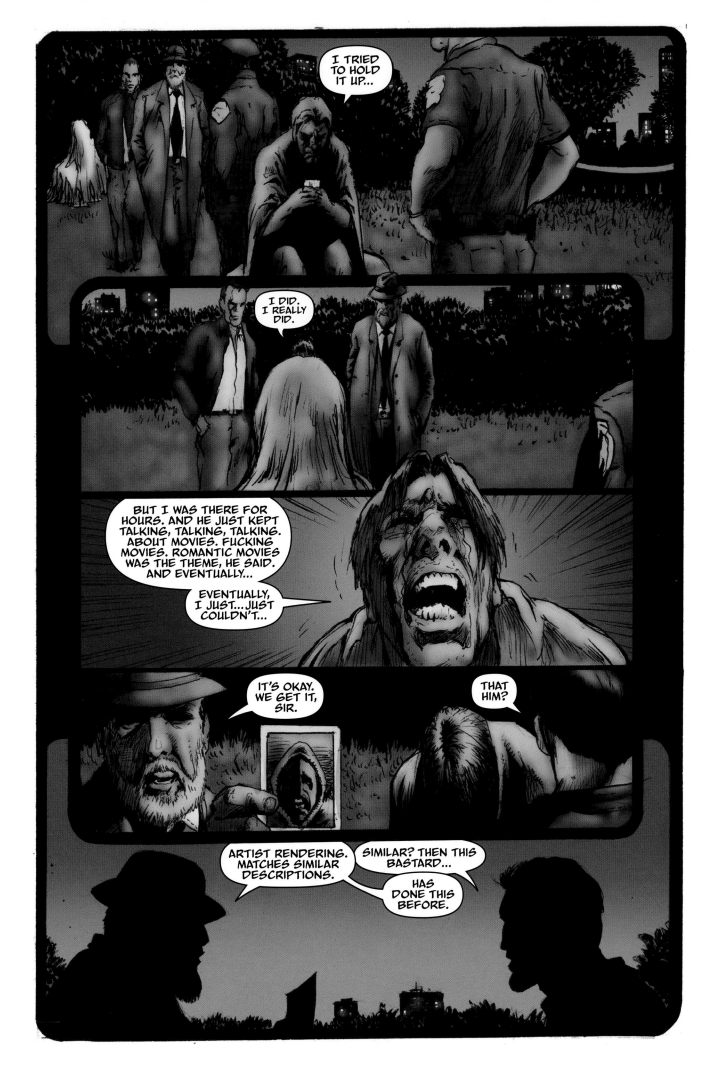

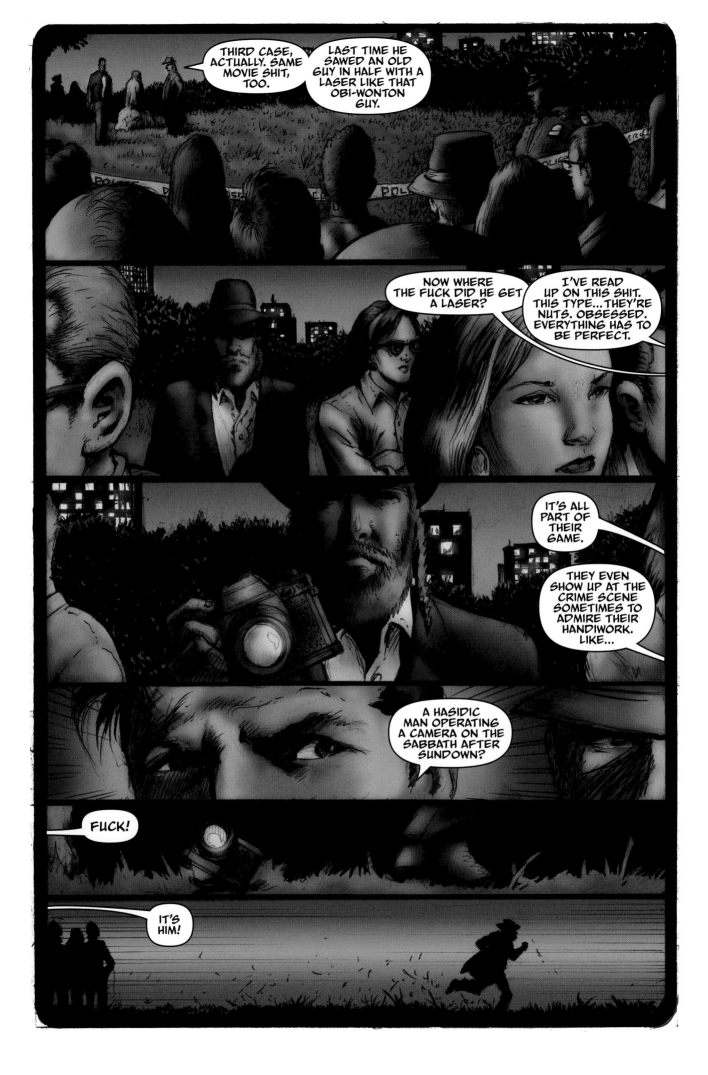

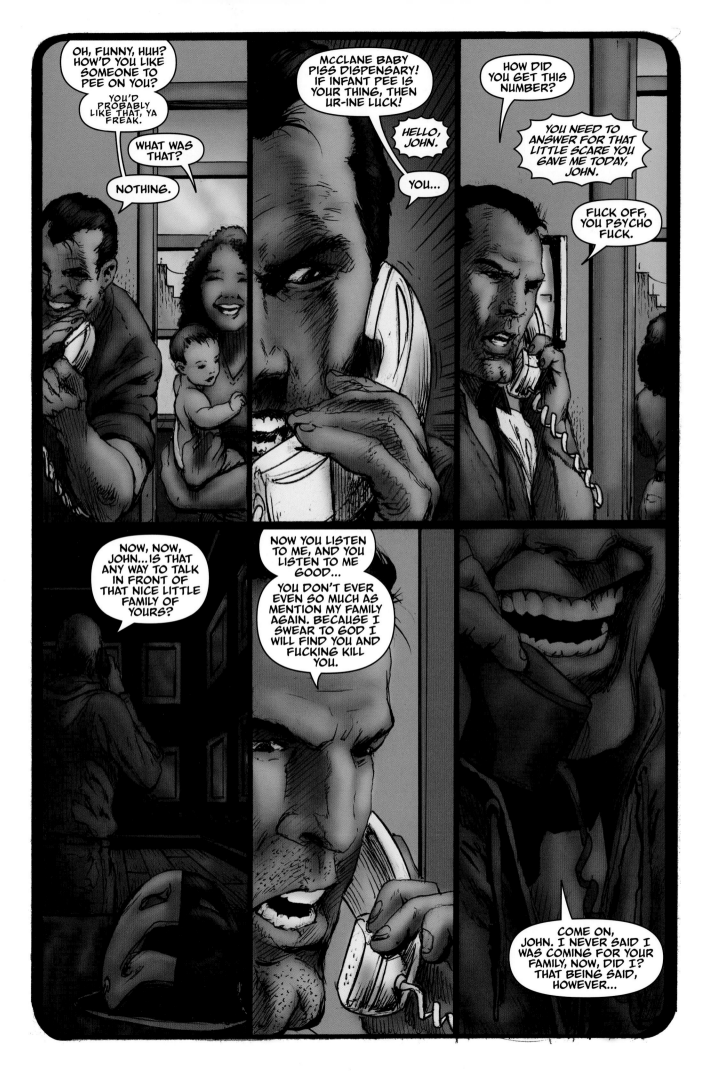

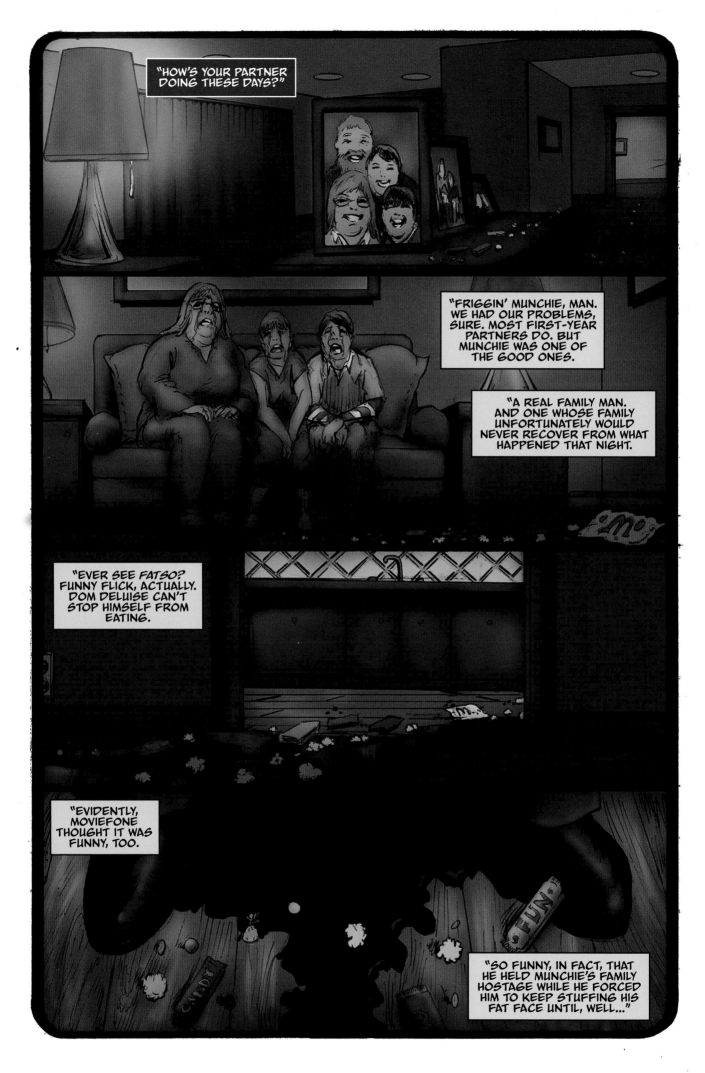

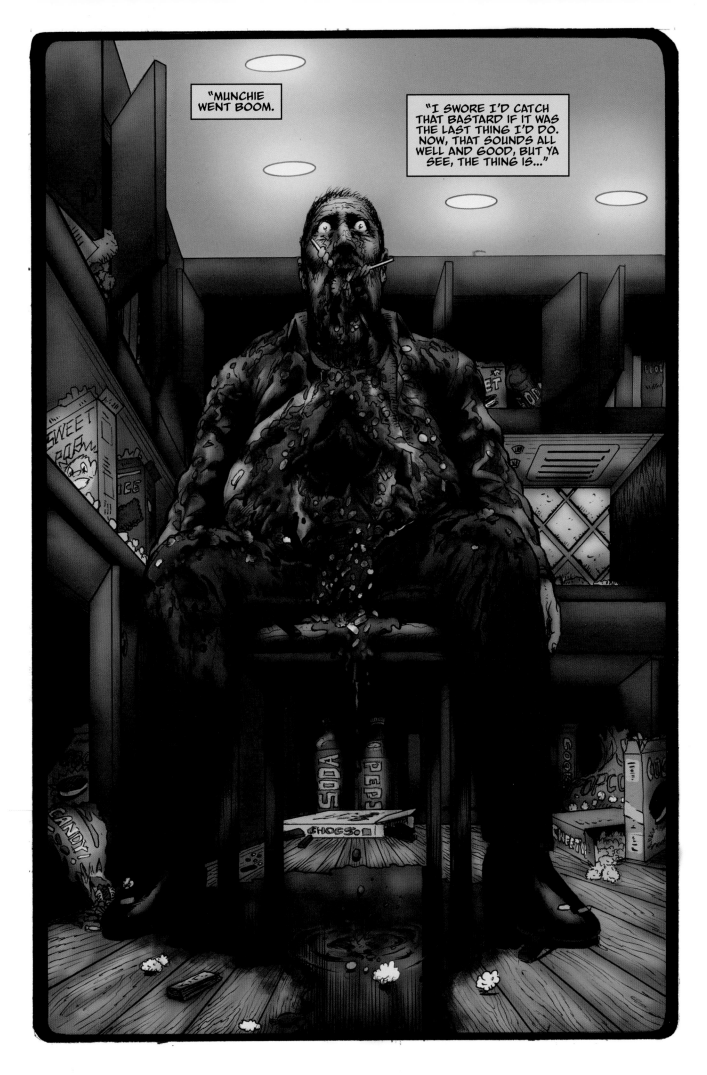

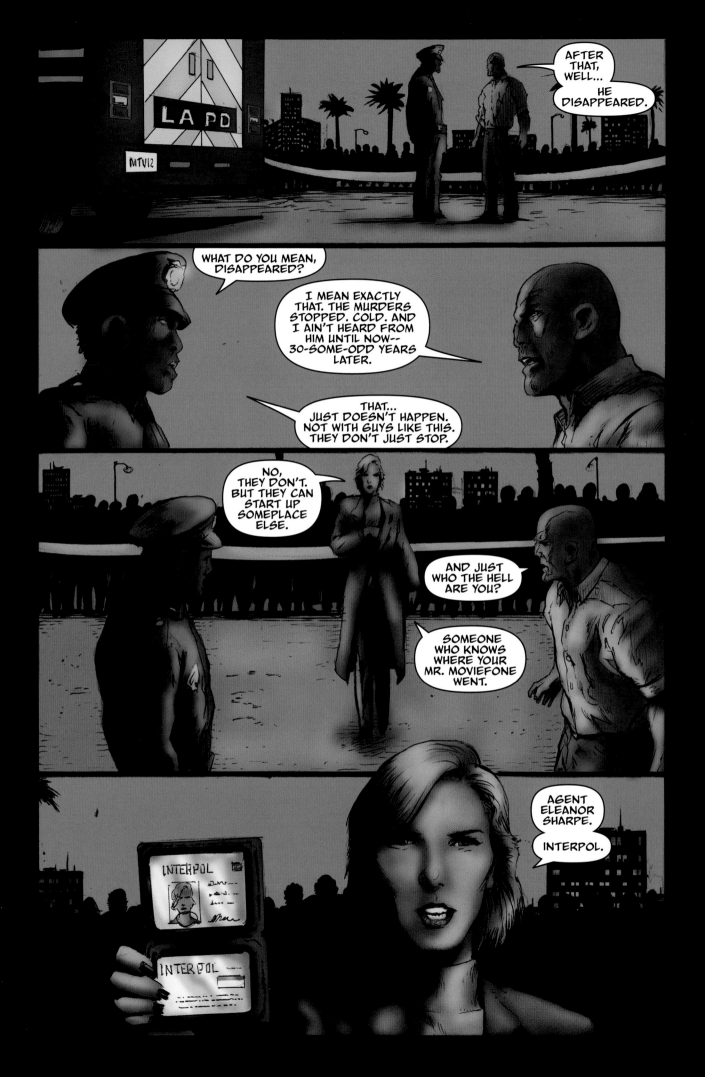

CHAPTER 3

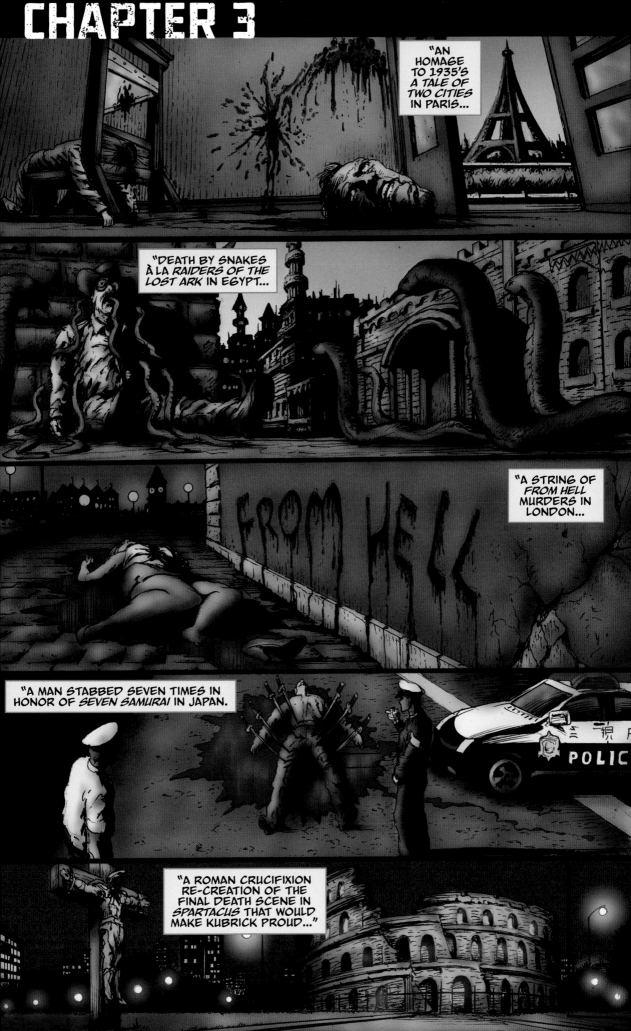

"AN HOMAGE TO 1935'S *A TALE OF TWO CITIES* IN PARIS...

"DEATH BY SNAKES À LA *RAIDERS OF THE LOST ARK* IN EGYPT...

"A STRING OF *FROM HELL* MURDERS IN LONDON...

"A MAN STABBED SEVEN TIMES IN HONOR OF *SEVEN SAMURAI* IN JAPAN.

"A ROMAN CRUCIFIXION RE-CREATION OF THE FINAL DEATH SCENE IN *SPARTACUS* THAT WOULD MAKE KUBRICK PROUD..."

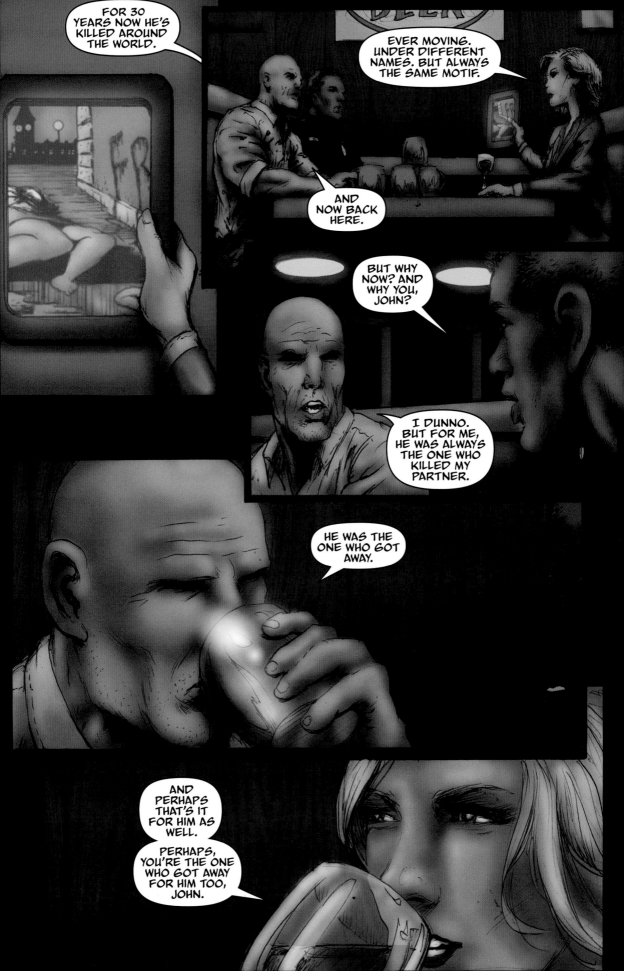

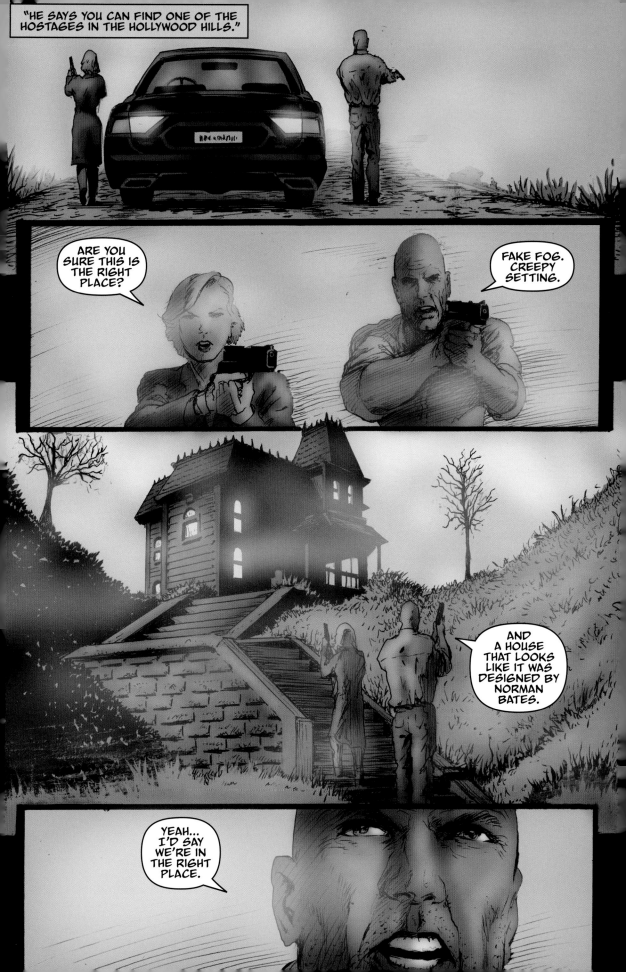

NO MOVIEFONE VOICE-OVER. JUST DEAD SILENCE. NOT THAT I MIND NOT HAVING TO HEAR THAT FUCKING PSYCHO.

PSYCHO IS APROPOS AS HORROR IS CLEARLY WHAT'S ON HIS MIND HERE. HE'S BUILDING TENSION, KEEPING HIS AUDIENCE IN SUSPENSE, UNTIL THAT MOMENT WHEN--

AAAHHH!

SLLSHHH

BLAM BLAM BLAM BLAM.

SHIT. DON'T TELL ME THIS IS ACTUALLY OVER...

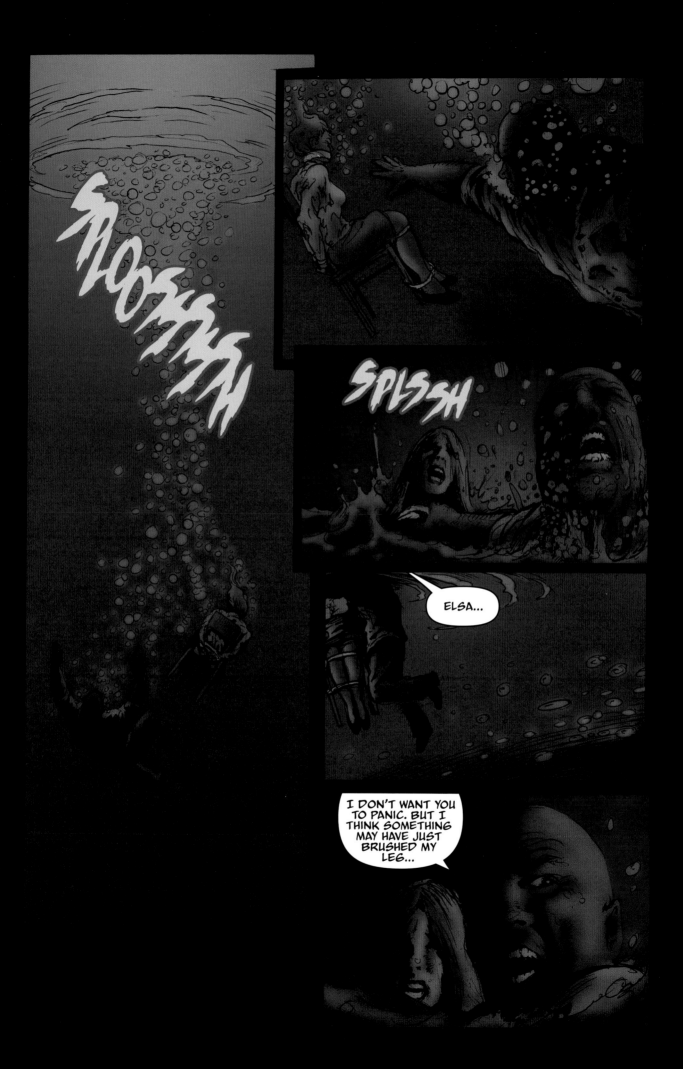

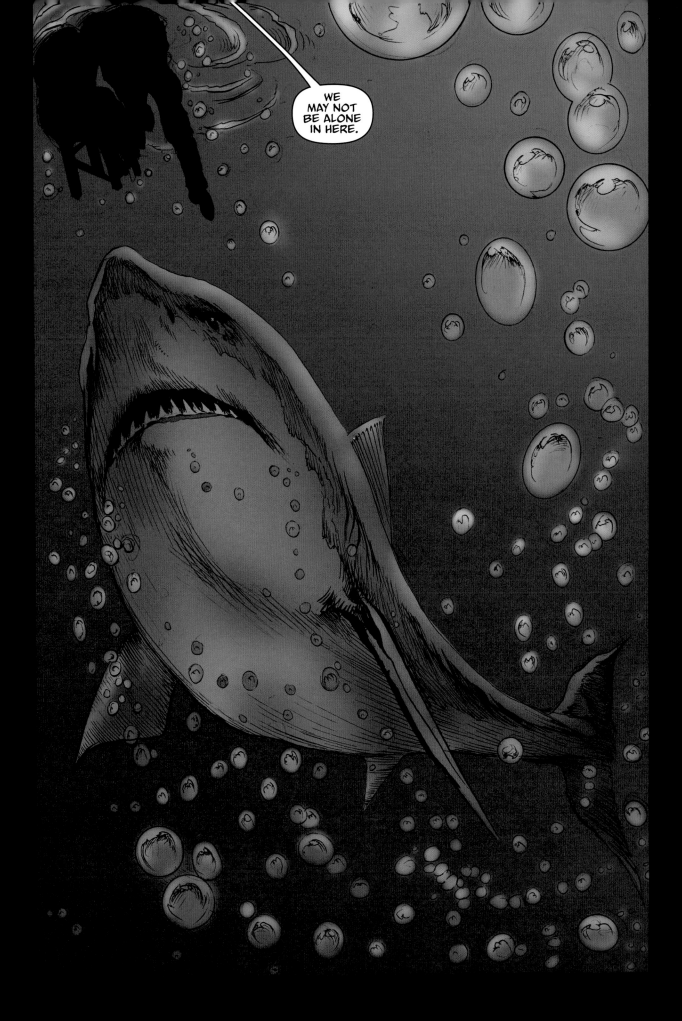

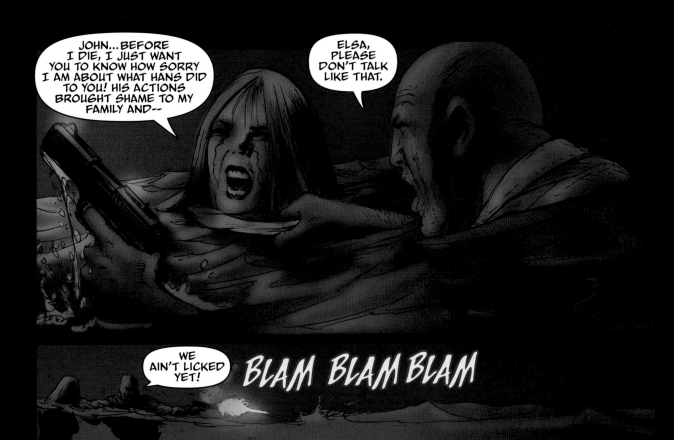

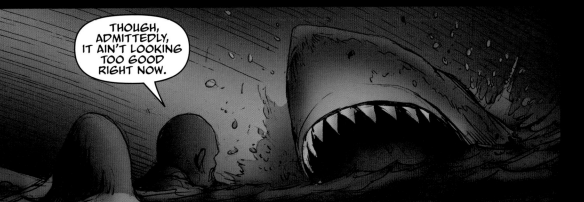

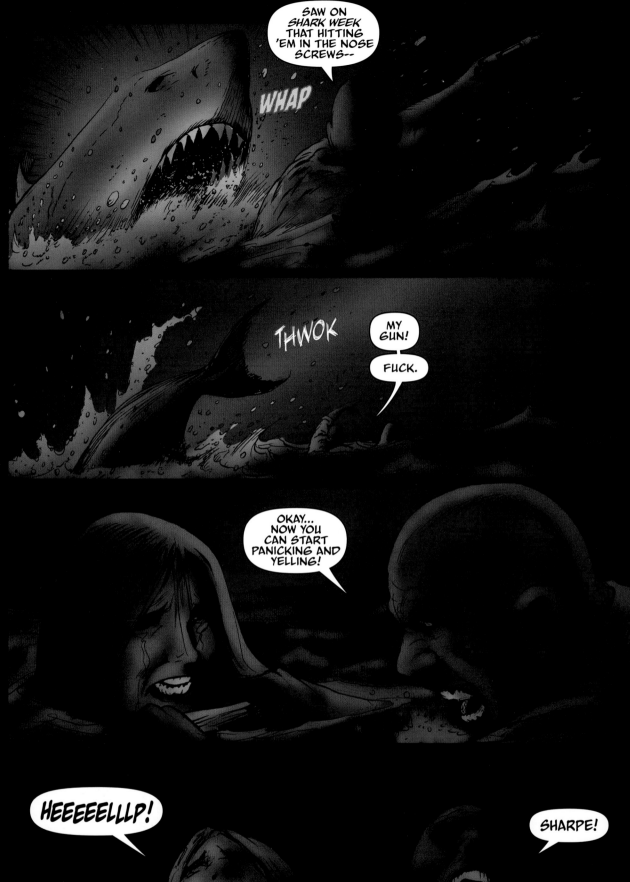
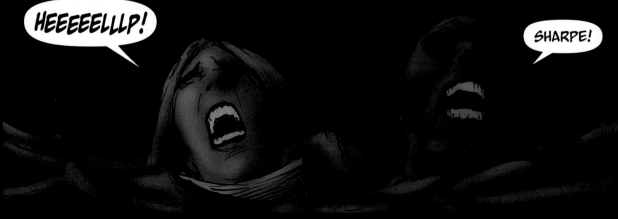

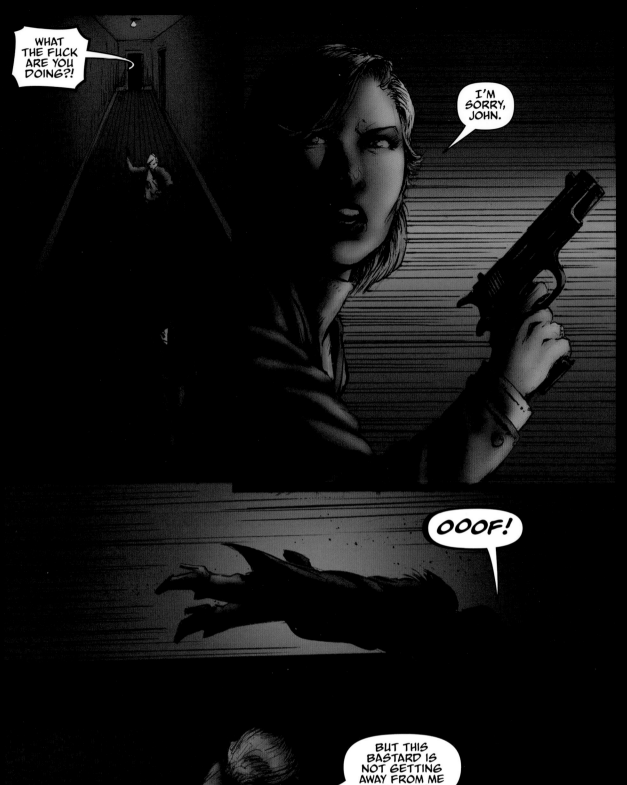

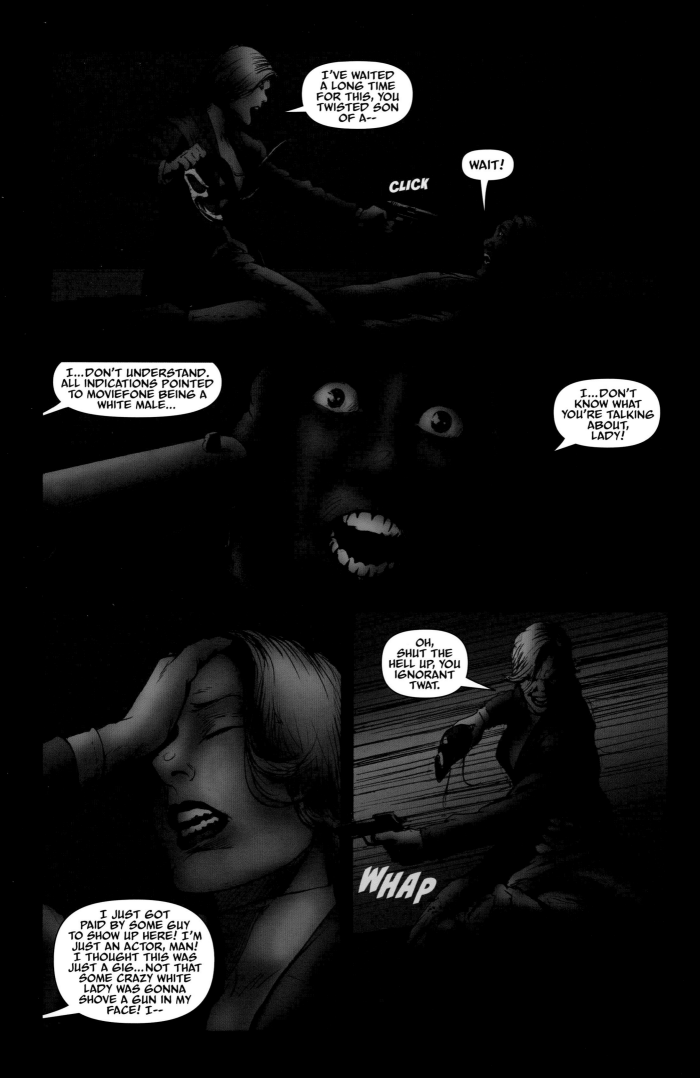

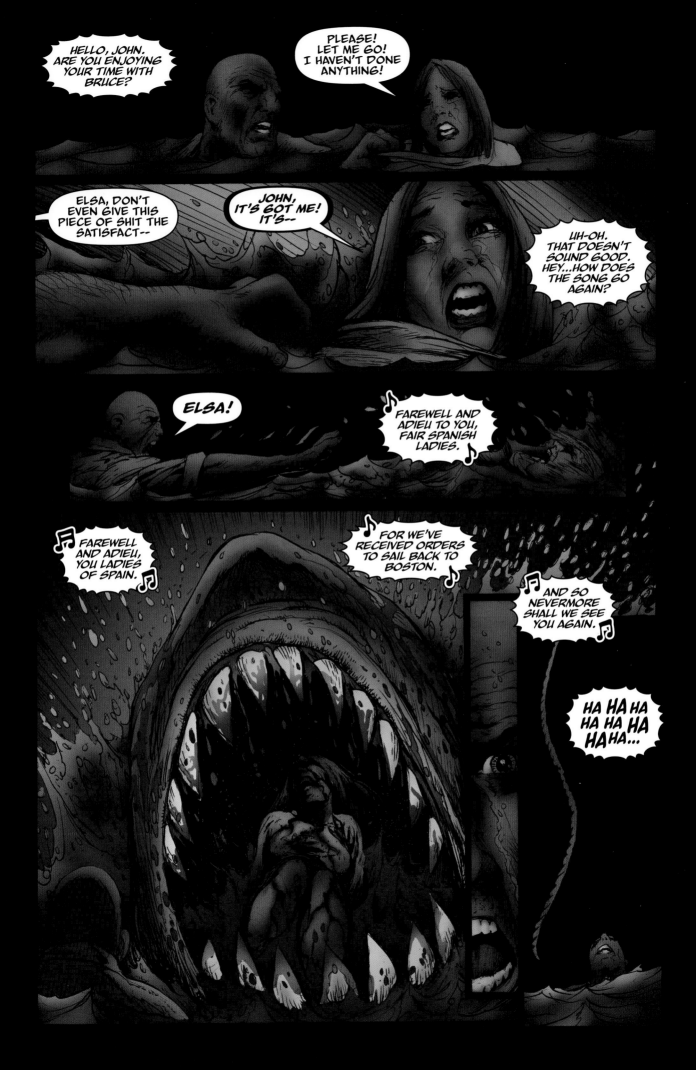

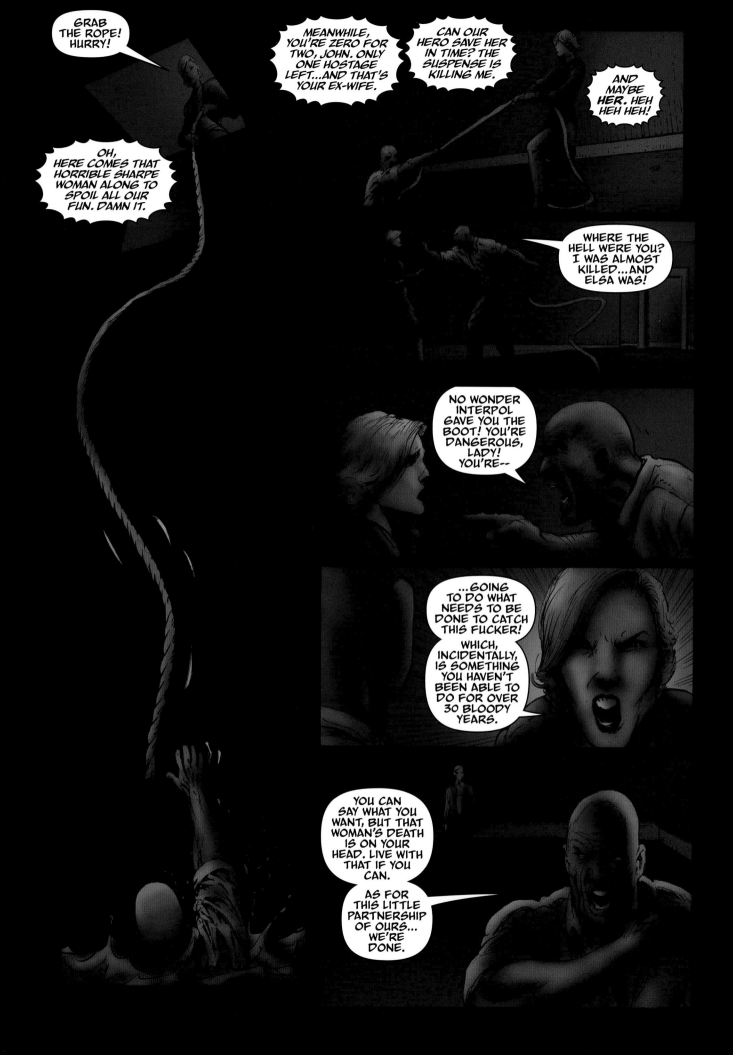

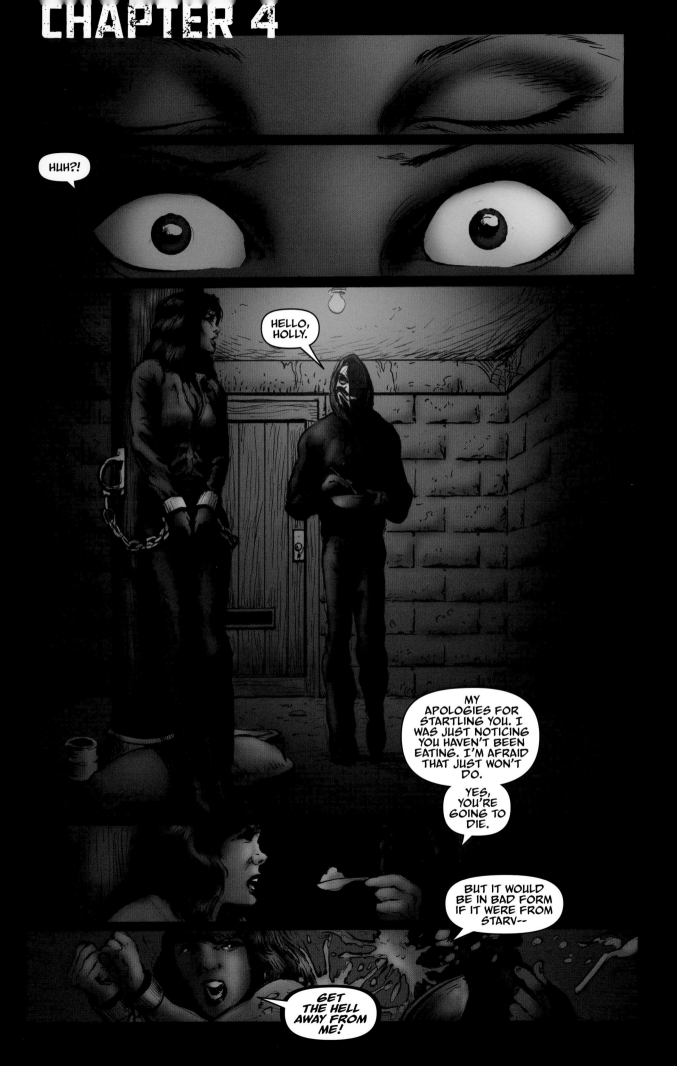

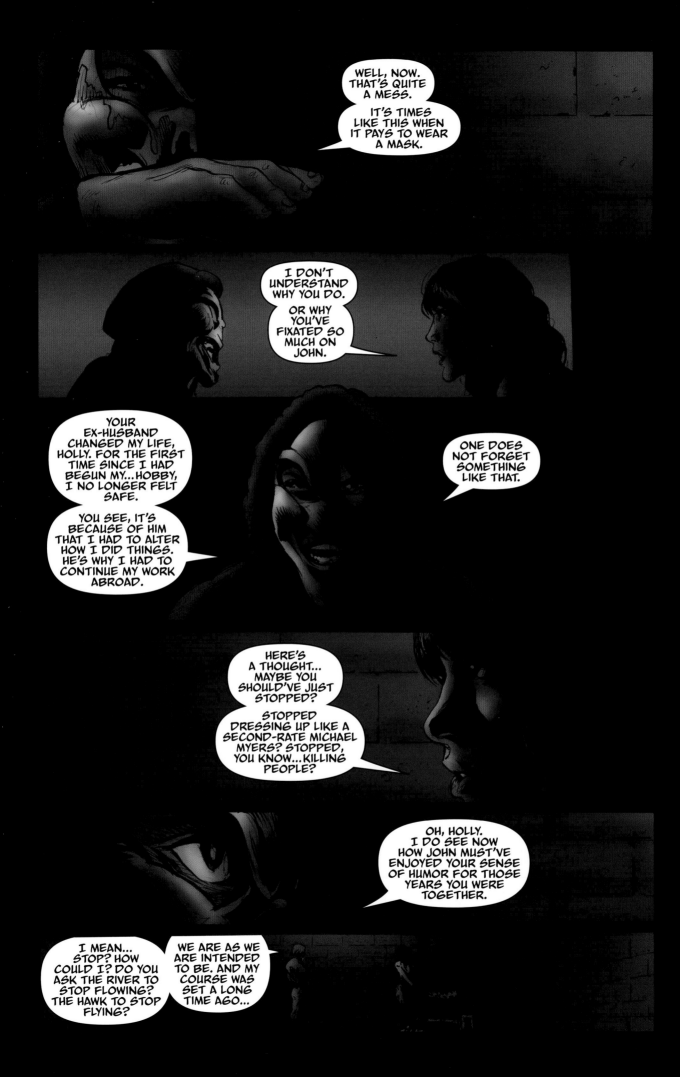

"WHEN I WAS A BOY, MY FATHER WOULD TAKE ME TO THE MOVIES.

"IT'S WHERE HE...WORKED.

"IT'S WHERE THE WORLD WAS OPENED UP WIDE TO ME.

"CRIME NOIR.

"ACTION.

"ADVENTURE."

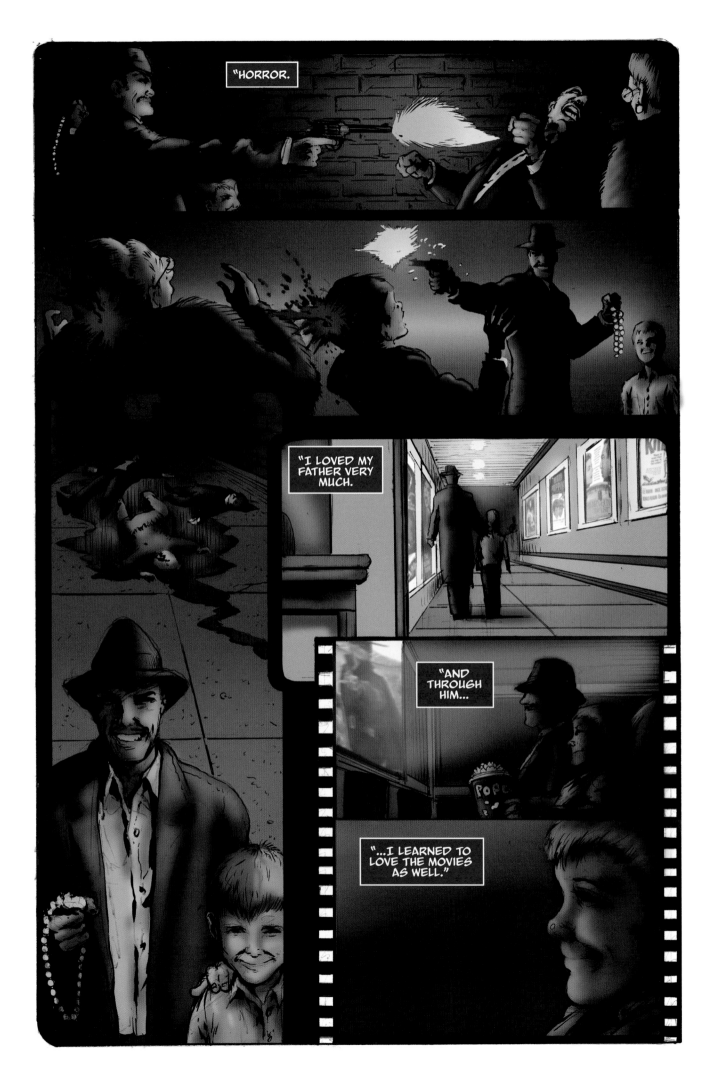

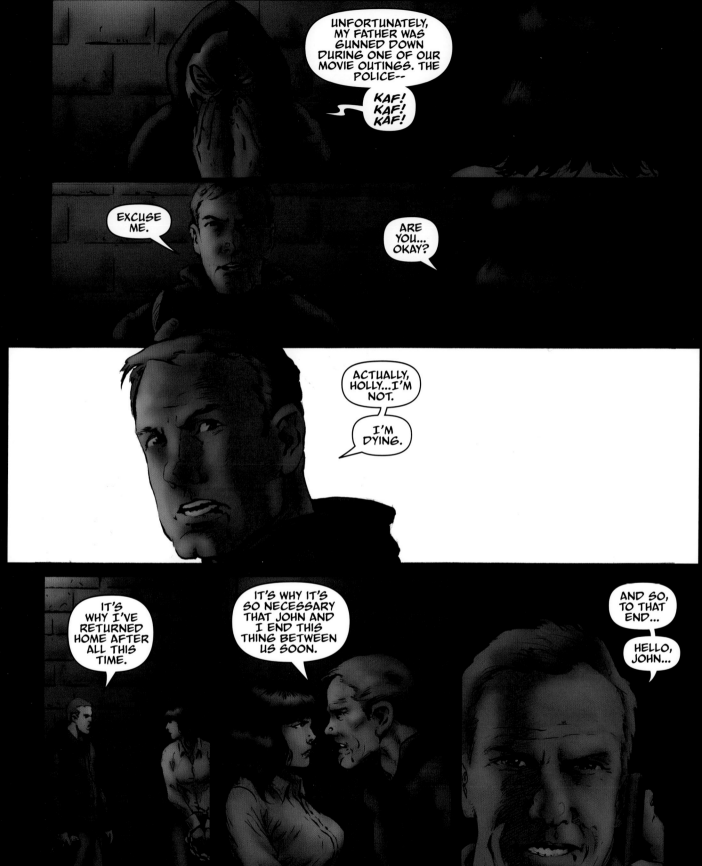

"HOLLY AND I WILL BE AT THE THEATER LATER THIS EVENING.

"WE WOULD LOVE FOR YOU TO JOIN US, JOHN.

THEATER

"AFTER ALL...

"...IT JUST WOULDN'T BE A GRAND FINALE WITHOUT YOU."

I'M SORRY, JOHN. IT WAS HARD TO GET A REAL AUDIENCE IN TIME FOR OUR CEREMONY...

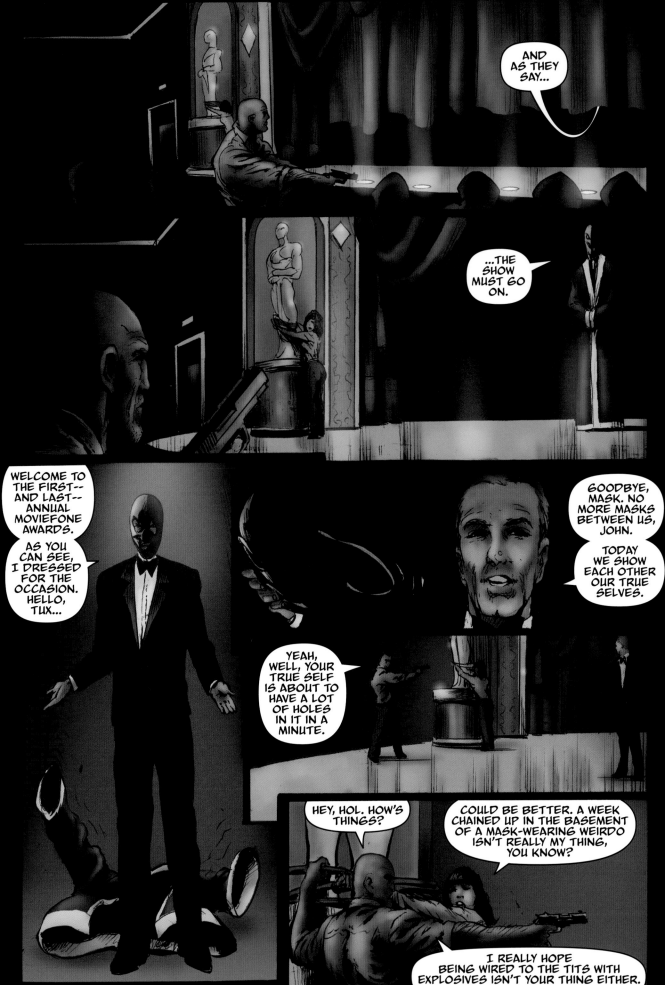

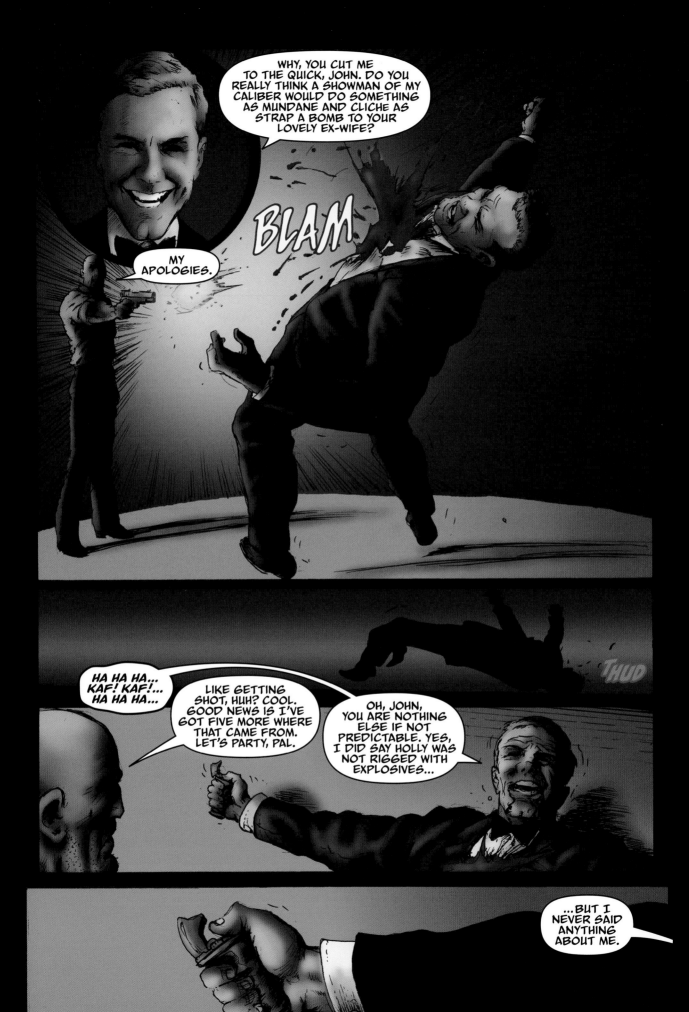

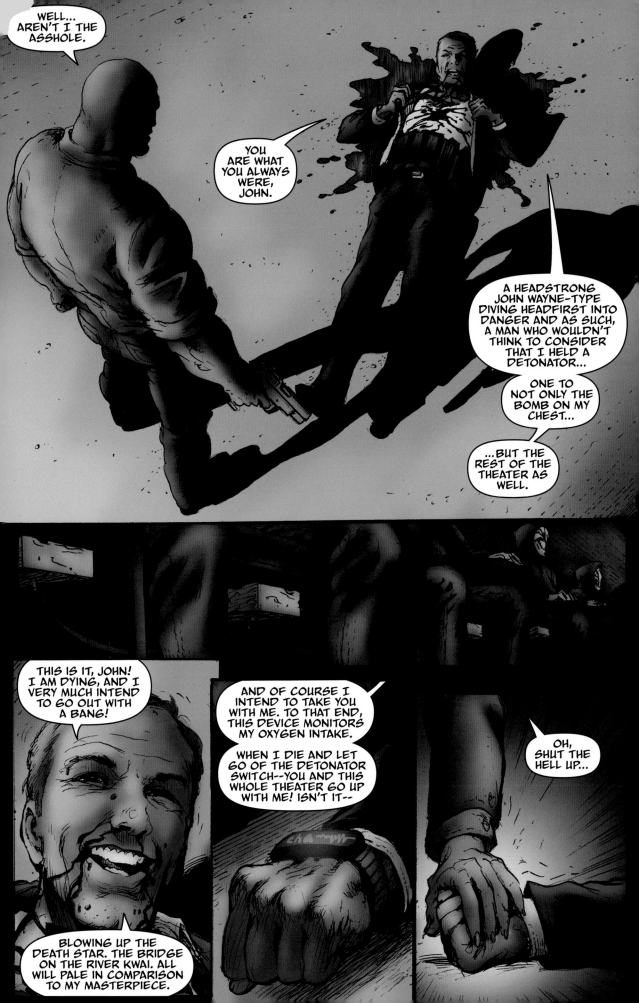

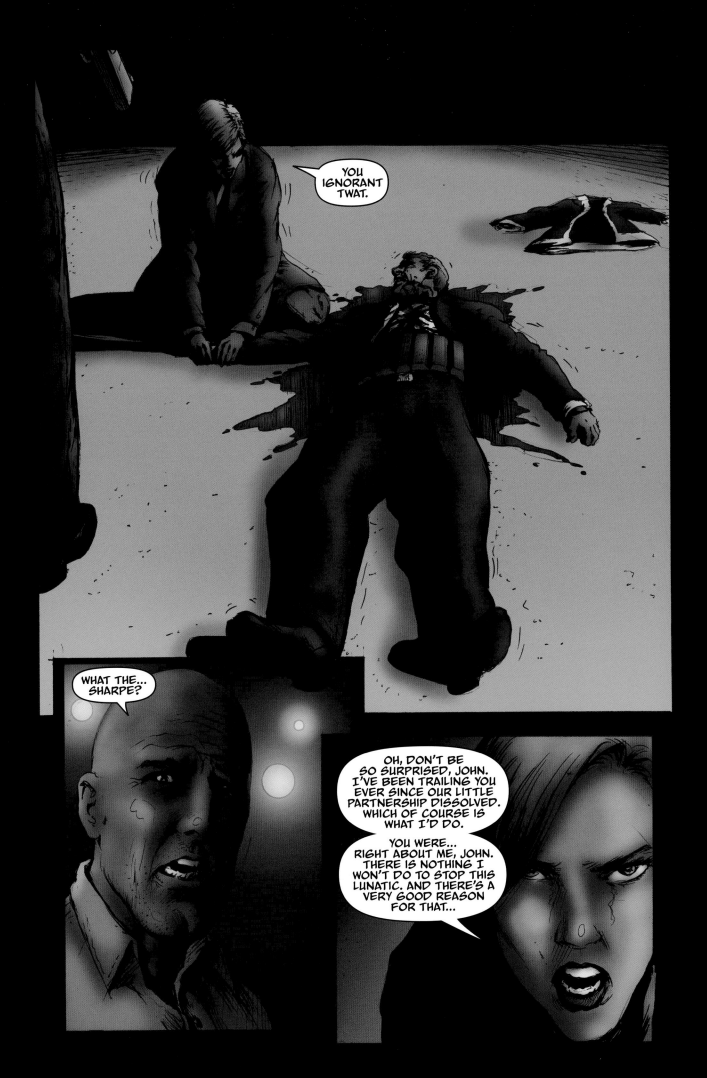

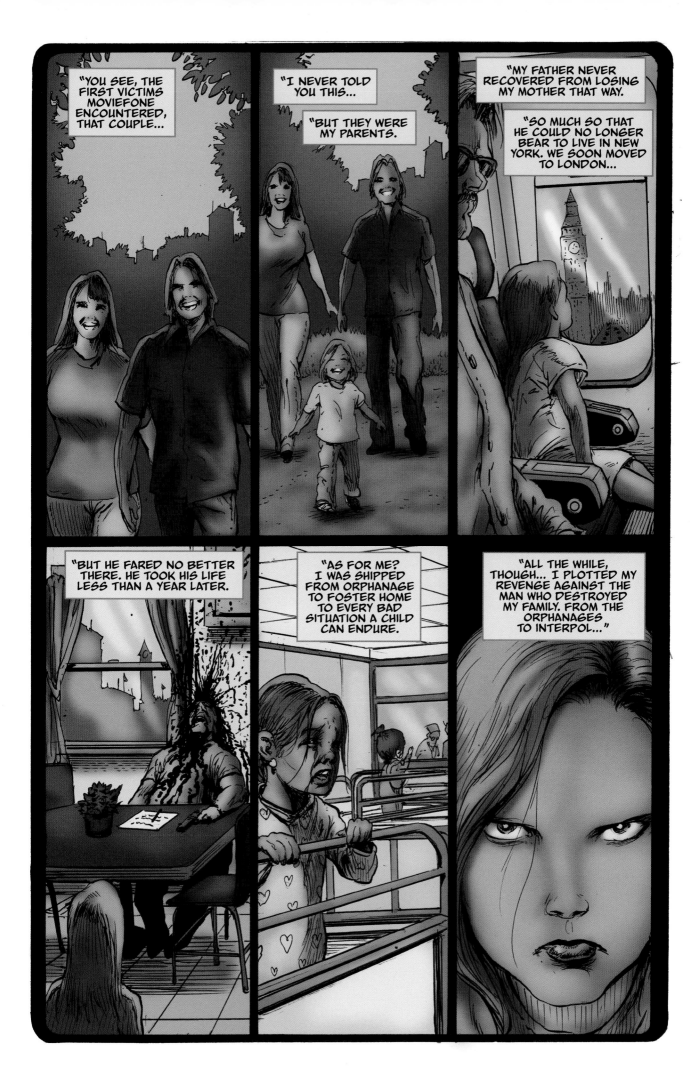

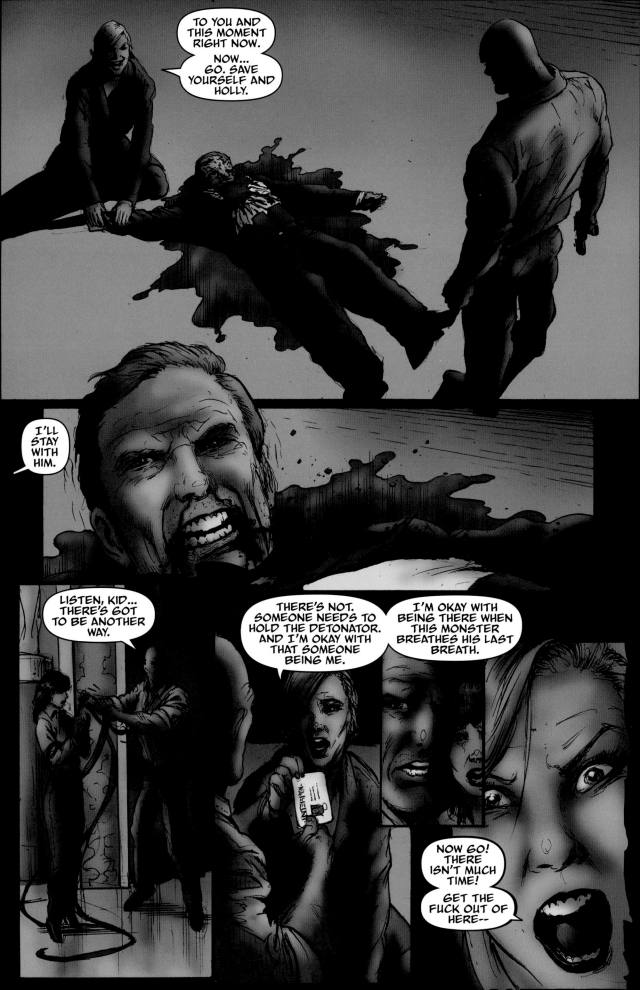

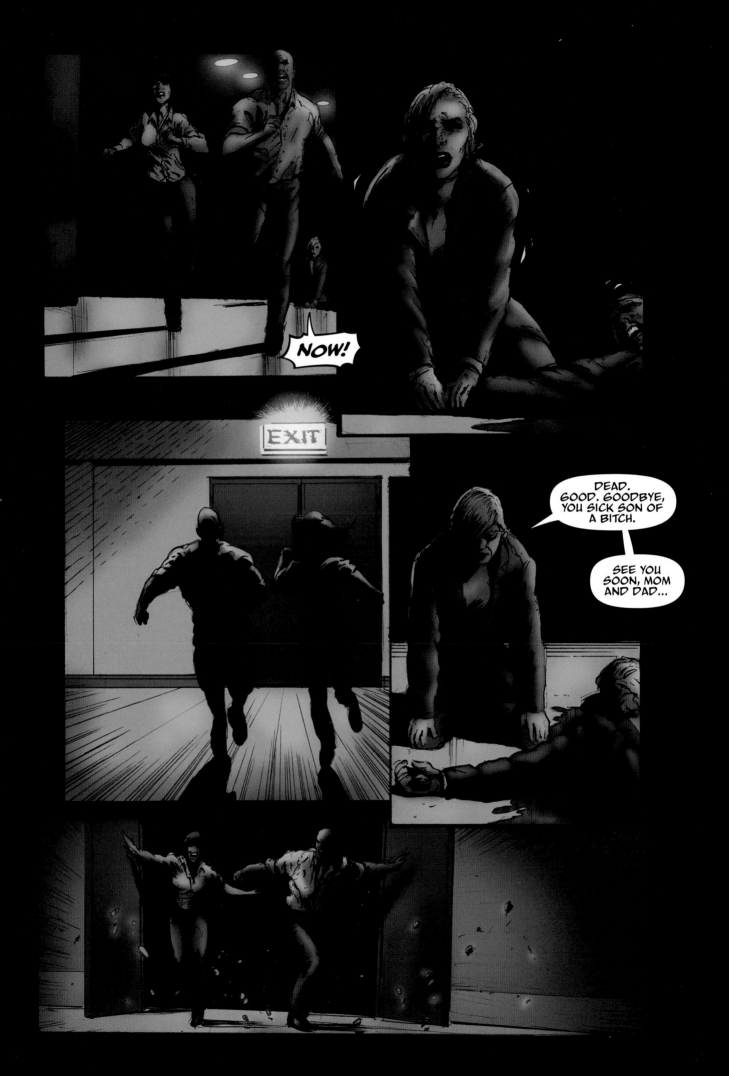

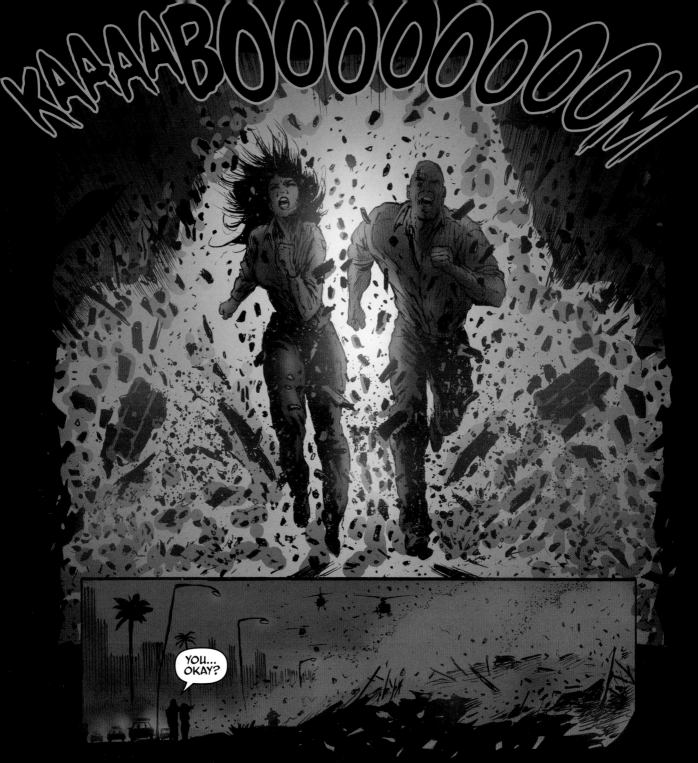

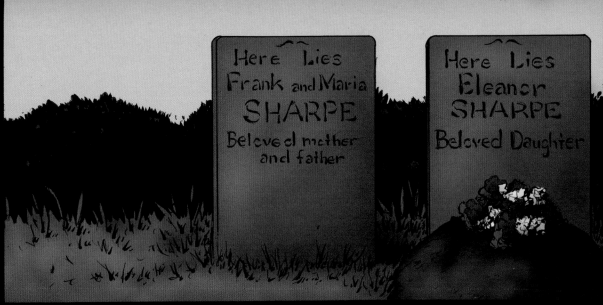

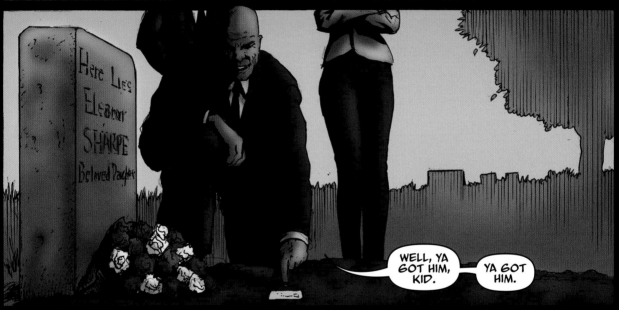

End.

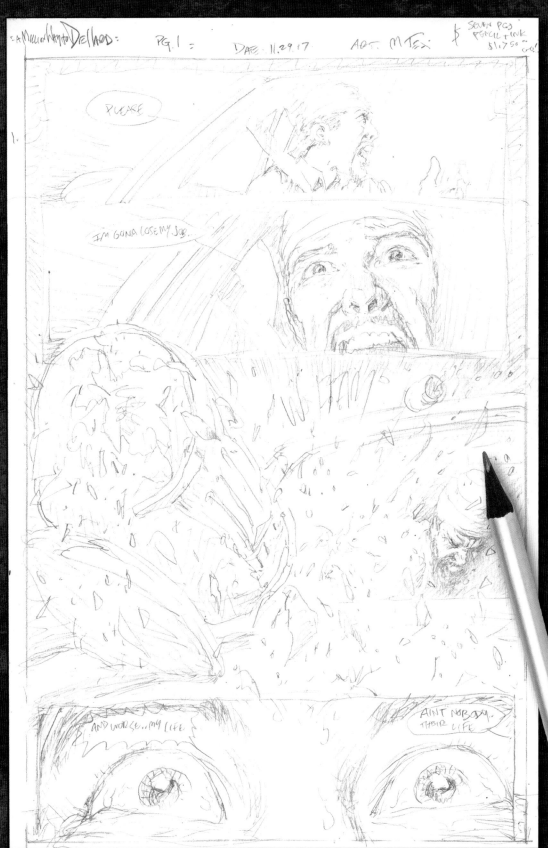

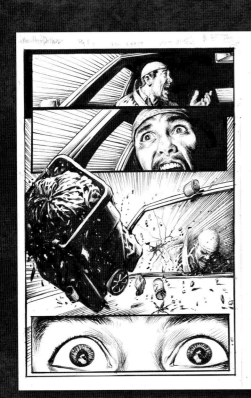

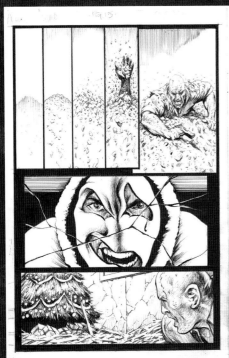

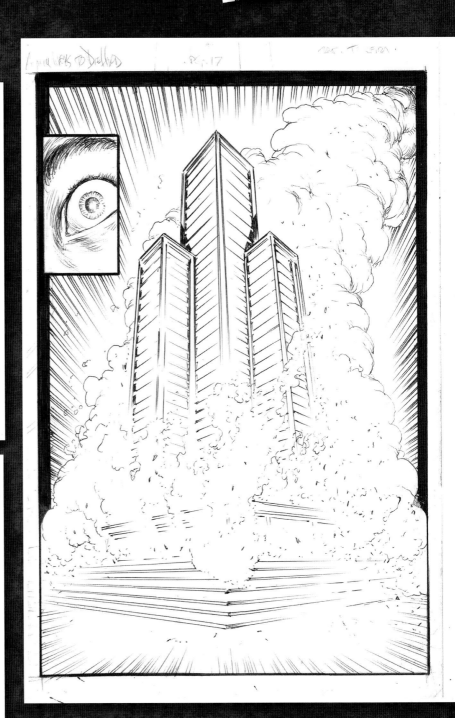

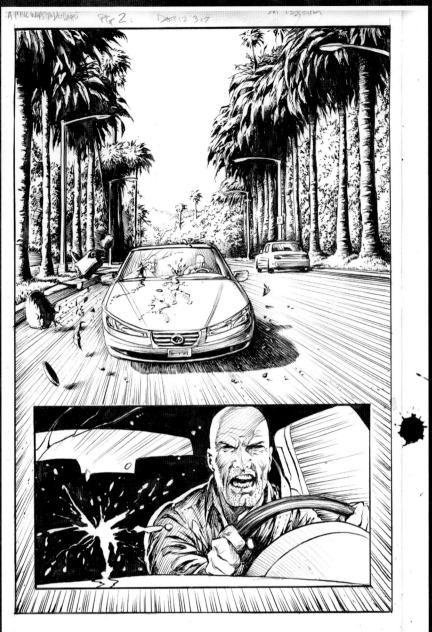

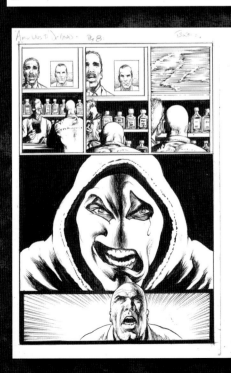

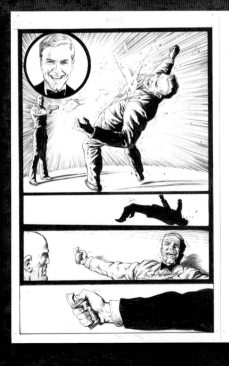

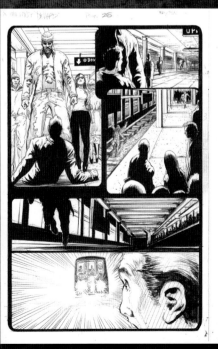

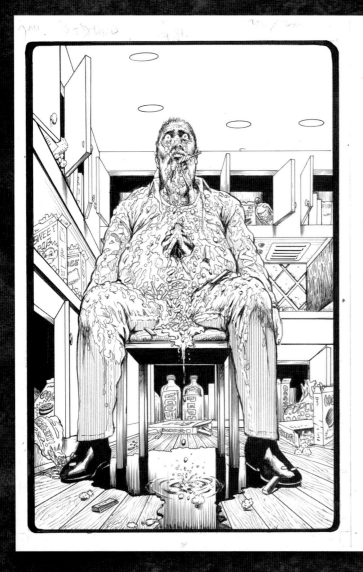

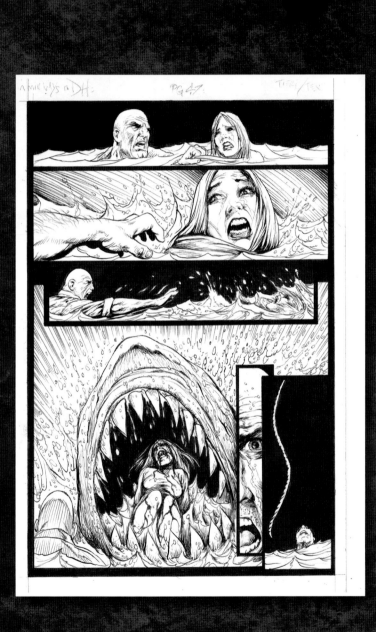

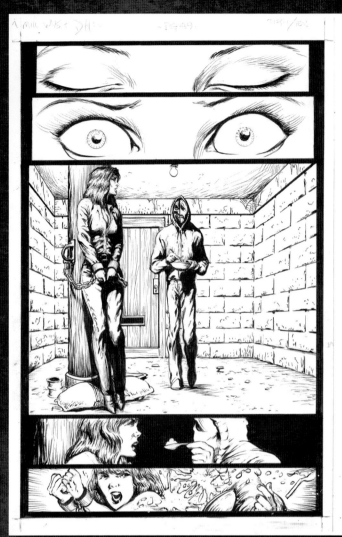

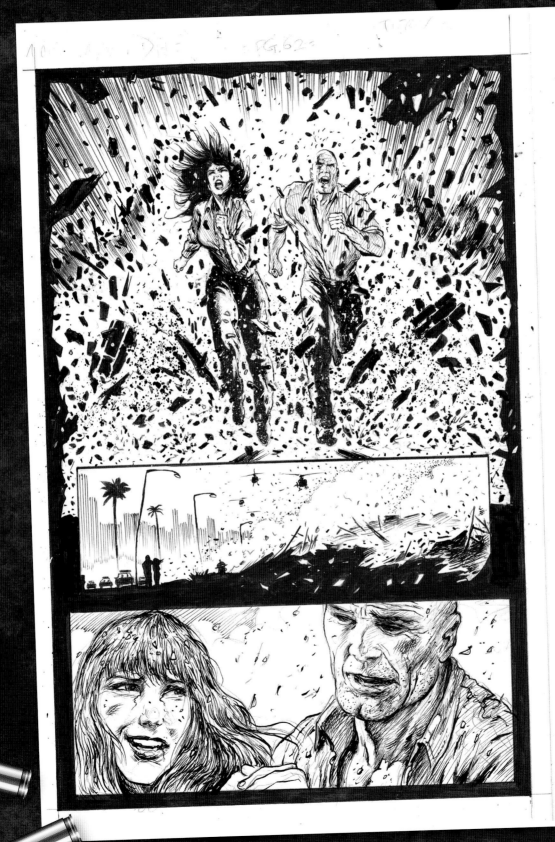

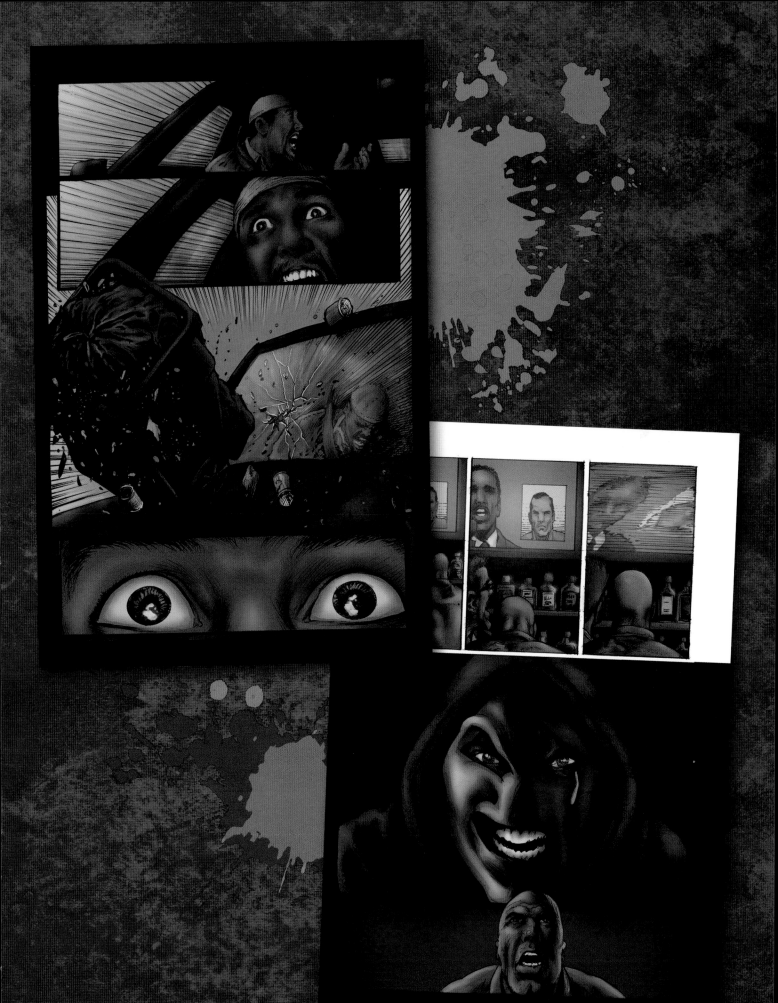

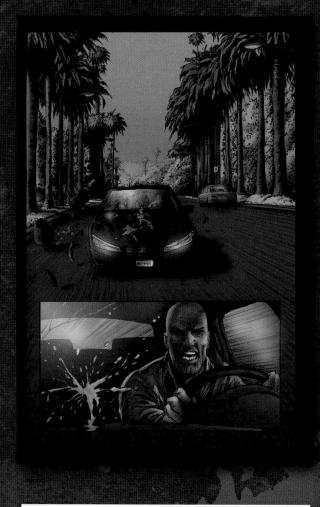

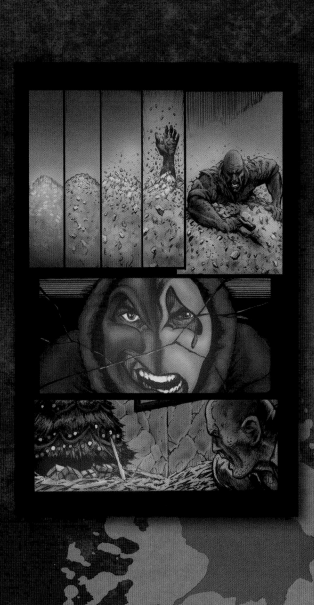

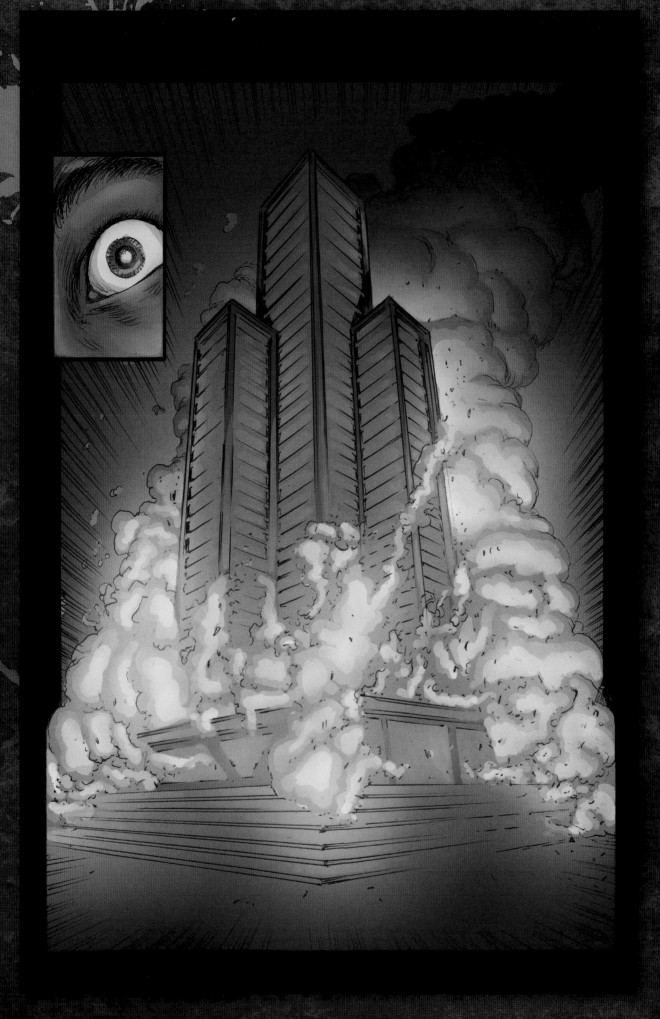